Fabergé Eggs

Fabergé Eggs

MASTERPIECES FROM CZARIST RUSSIA

Susanna Pfeffer

Hugh Lauter Levin Associates, Inc.

Distributed by Macmillan Publishing Company, New York

PHOTOGRAPHY CREDITS

Photographs from the *Forbes* Magazine Collection, New York:
Murray Alcosser (Coronation Egg), H. Peter Curran, Larry Stein.
Monogram Egg (cover), Edward Owen, Hillwood Museum.
Pine Cone Egg courtesy Christie, Manson & Woods International, Inc.
Photographs from Soviet Collections
© George Ginzburg, 1990.

INTRODUCTION

FABERGÉ
AND THE ROMANOVS

The exchange of decorated eggs—usually dyed or painted—as gifts at Easter has been a tradition in Eastern Europe for hundreds of years. In Russia, where the Orthodox Easter is the most important religious holiday of the year, the decorated egg assumes even greater significance. A symbol of new life as well as of resurrection, the egg is the quintessential Easter gift, epitomizing the time of rebirth in the Christian calendar. In terms of sheer luxury, the giving of decorated eggs achieved its zenith during the reigns of Czars Alexander III and Nicholas II—the last of Russia's royal family, the Romanovs.

In 1885, Czar Alexander ordered from the house of Fabergé the First Imperial Egg, which he presented to his wife Marie Feodorovna as an Easter gift. Each year thereafter, he ordered another egg until his untimely death, at the age of forty-nine, in 1894. From 1895 until 1916, his son Czar Nicholas II carried on the tradition begun by his father by commissioning not one but two Easter eggs annually, one for his wife Czarina Alexandra Feodorovna and one for his mother, the Dowager Empress. Because of the upheavals of the Russian Revolution and subsequent events, it has never been established just how many imperial eggs were made and presented, but most authorities agree that there were between fifty-four and fifty-seven imperial eggs. Some were irretrievably lost in the aftermath of the Revolution, but in the years since, forty-five or so have surfaced and are now in museums or in the hands of private collectors in the Soviet Union, Europe, and the United States.

Exactly how Fabergé came to produce his incomparable series of eggs for the Czars is a matter of speculation. It is known that Czar Alexander III was an admirer of Fabergé and had already commissioned works from him before

ordering the first egg. But whether it was the emperor or the jeweler who made the initial overtures with regard to the eggs is not clear. What cannot be disputed is that Fabergé's name and enduring reputation are irrevocably linked with the last of the Romanovs.

FABERGÉ'S LIFE

Peter Carl Fabergé was born in St. Petersburg in 1846. His antecedents were French Huguenots who, because of religious persecution, were forced to leave France; they eventually migrated to Russia. His father Gustav, a jeweler, settled in St. Petersburg, where he opened his own business on Bolshaya Morskaya Street in 1842. Peter Carl (or Karl Gustavovich, in the Russian style) began his

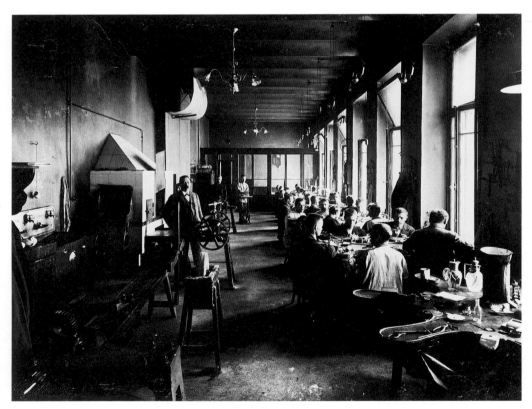

Interior of Michael Perchin's workshop in St. Petersburg, ca. 1900.
Courtesy Wartski, London.

education in the city of his birth, but when his father retired in 1860 and moved to Dresden, he continued his studies there and in Frankfurt. He also traveled to Italy, England, and France, where he received training in business as well as in the making of jewelry.

In 1870, Peter Carl Fabergé returned to St. Petersburg and, along with his brother Agathon, took over his father's firm from the partners to whom it had been temporarily entrusted. Two years later he married; he and his wife had four sons, all of whom eventually joined the firm. The business did well; other branches were opened, including one in Moscow in 1887 and one in London in 1906. By 1890, the firm had moved to larger quarters on the same street as the original shop. The new building housed not only the sales shop itself, but workshops and living quarters for the Fabergé family as well as for some of the workmasters. The house of Fabergé continued to flourish, but World War I and then the Russian Revolution took their toll. First the branches were forced to shut down, and later, in St. Petersburg, after being taken over by a people's committee in 1917, the house of Fabergé finally closed its doors forever in 1918. Along with his wife and family, Fabergé managed to escape from Russia. They eventually made their way to Switzerland, settling in 1920 in Lausanne, where Peter Carl Fabergé died in September of that year.

FABERGÉ'S CLIENTELE AND PRODUCTION

Fabergé's patrons included the royalty and aristocracy of Europe and Russia, the most illustrious being the last two Czars, Alexander III and Nicholas II. For his royal clients, he turned out *objets d'art* and *objets de luxe*: cigarette cases, picture frames, tableware, miniature furniture, carved animals and figurines, umbrella handles, boxes, and, of course, brooches, necklaces, and other personal adornments. In later years, his reputation extended even to the Far East; he executed several commissions for the King of Siam (Thailand). Affluent business clients also patronized the house of Fabergé; probably the most eminent among these was Alexander Ferdinandovich Kelch, whose wealth derived from gold-mining interests in the Ural Mountains. Over a period of several years, Kelch ordered a series of eggs as gifts for his wife, the former Barbara Bazanov. The Kelch eggs rivaled the imperial eggs in design, workmanship, and quality of materials.

Although Fabergé apprenticed and was qualified as a master goldsmith, he did not himself actually fabricate the famous eggs and other works that bear his name, though he was directly involved in the design of all pieces. The actual production was left to his workmasters and their craftsmen, who worked under his close supervision. At the height of his firm's success, Fabergé employed about 500 workers. In St. Petersburg, where the imperial eggs were produced, his most famous workmasters were Erik Kollin, a Finn; Michael Perchin, a Russian; Henrik Wigström, August Holmström, and August Hollming, also Finns; and Alfred Thielemann, a German. Each of these workmasters had a personal mark with which he signed his work. Since most, though not all, of the imperial eggs were signed, it is possible to attribute and date many of them more or less precisely.

THE MANY-SPLENDORED EGG

Artistic, imaginative, and endlessly inventive, Fabergé produced numerous and astonishingly original variations on the basic theme of the egg. Thus, through his use of a variety of materials, techniques, styles, ornamentation, and sizes—from a miniature five-eighths of an inch, to a nearly life-size two and one-half inches, to over fourteen inches—he was constantly challenging and then surpassing himself.

For the materials of the basic egg, Fabergé made much use of gold, both by itself and in combination with silver, platinum, and hardstones such as rock crystal, jasper, agate, bowenite, and nephrite. Occasionally he even used blued steel. He ingeniously used an old goldsmithing technique of adding other minerals to molten gold to produce tints: white (with nickel or palladium), red (with copper), and green (with silver) in addition to the natural yellow. By using two, three, or all four colors of gold in a single piece, he was able to produce sometimes subtle, sometimes striking, effects.

As for ornamentation, the house of Fabergé was noted above all for its enamel work. The technique of enameling is a tricky, exacting process that requires the utmost skill, and, while known and practiced elsewhere for years, it was refined and brought to perfection by Fabergé and his workmasters. As practiced by Fabergé, a mixture of glass and metal oxide, heated to a very high temperature so that it became fluid, was applied to a metal surface. When cooled, it hardened and was then polished by hand to a glassy smoothness. Successive coats were applied in the same manner. While enameling a flat surface

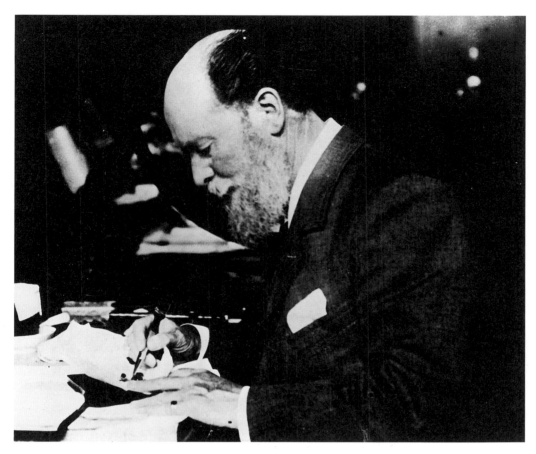

Carl Fabergé sorting through a parcel of loose stones, ca. 1915.
Photograph by Hugo Oeberg, one of his designers in St. Petersburg.
Photograph courtesy of Wartski, London.

was already difficult, Fabergé went one better and earned a reputation for flawless enamel work on the curved surfaces of his eggs. It is said that Fabergé examined every enameled piece and that if he detected the slightest flaw he would smash it with a hammer kept especially for that purpose.

Fabergé was always searching for new enamel colors, and he is thought to have developed, through experimentation, over 100 colors. Depending on the desired effect, he used opaque, transparent, or opalescent enamels. The latter was achieved by applying a first coat of semitransparent colored enamel and then adding coats of clear white. To enhance the transparent or opalescent effects, the basic metal surface, usually silver or gold, was often engraved with a pattern by means of a lathe-like machine known as a *tour à guilloche*, from

which the term *guilloché* (engraved by machine) derives. The design, visible through the enamel, would catch the light and add depth and richness to the enameling. Moiré and basket-weave designs were among the most frequently used *guilloché* patterns. Often the enamel color determined which precious metal was to be used as the underlying surface, or ground; many colors were more effective over silver than over gold.

In the decorative scheme of the imperial eggs, the basic enamel technique was often supplemented with variations such as champlevé and *plique-à-jour*. Incidentally, although Fabergé was a master of cloisonné as well, he did not use this style of enameling for the Easter eggs. The enamel work of the First Imperial Egg has an opaque, matte finish in white, much like a real egg. Many subsequent eggs were finished in jewel-toned translucent enamel over a *guilloché* ground; the red Imperial Spring Flowers Egg is but one example. Sometimes the egg was painted with a design that was visible through the top layer of clear enamel, as in the Imperial Gatchina Palace Egg. One of the most spectacular eggs is the Imperial Clover Egg, an Art Nouveau–style piece featuring the use of *plique-à-jour* enameling.

Although the majority of the eggs bear at least some enamel work, they have been lavished with many other decorative devices as well, such as gold cagework, engraving and chasing, latticework, and a profuse deployment of precious stones such as diamonds, rubies, sapphires, and pearls.

One striking feature of the eggs that is a favorite with most Fabergé admirers is the surprises. Fabergé himself may not have originated the idea of hiding a little toy, jewel, or miniature replica inside (or, in some cases, outside) of the egg, but under his guidance the practice flourished and was most delightfully realized.

Finally, there is the unique Fabergé *style* that pervades all the work of his firm, not just the imperial eggs. True, Fabergé borrowed liberally from recognized periods and styles—classical, Renaissance, baroque, rococo, Louis XV and XVI, Empire, Art Nouveau, traditional Russian—but always with his own twist or interpretation and almost always with restraint, so that the end result was never merely imitative, but took an inspiration and transformed and embodied it into an original, remarkable work of art—rich, to be sure, but never flashy. The emphasis was always on overall visual impact and exquisite craftsmanship rather than on ostentatious use of precious metals and stones. Not that he used inferior materials; he did not. But he chose his materials for their contribution to the ensemble, not for their intrinsic value. Thus, rather than an expanse of gold, he would use colorful enamel, and instead of large, perfect gemstones, he would use numerous smaller stones, such as the less expensive

rose diamonds, to create a striking pattern or design. A good illustration of this philosophy of "craftsmanship above all else" is the Imperial Mosaic Egg. Here, a framework of platinum mesh is completely filled in with tiny precious and semiprecious stones of various colors to create a mosaic floral design—a tour-de-force of technique in the service of beauty.

Nicolai Petrov, son of Alexander Petrov, described by Bainbridge as "a somewhat rough character, fully absorbed by his work" (Carl Fabergé, Goldsmith to the Imperial Court of Russia by A. Kenneth Snowman, 1979). Courtesy Wartski, London.

IMPERIAL EGG THEMES

Every imperial egg had its own theme. Some were purely personal, others marked some contemporary or historical event, or even a technological development. Thus, from studying the imperial eggs it is possible to follow the course of the reign of the last two Czars, to become acquainted with the principal individuals, and to gain an insight into their family life.

As an example of an egg with a personal theme, the First Imperial Egg was based on another egg with which the recipient, Marie Feodorovna, was familiar: a French ivory egg owned by her father, King Christian IX of Denmark. The Imperial Danish Palace Egg, another reminder of home, contained as its surprise a ten-panel screen of miniatures depicting various residences and yachts belonging to the Danish royal family. The coronation of Czar Nicholas II and Czarina Alexandra Feodorovna took place in 1896, and in the following year, the Imperial Coronation Egg commemorated that event. In another reference to the coronation, the Imperial Uspensky Cathedral Egg depicts in a fanciful manner the walls of the Kremlin and the cathedral within the compound where the czar was crowned. And the Imperial Fifteenth Anniversary Egg, which in 1911 marked the fifteen years of Nicholas's reign, depicts the important events of those years as well as the members of the Czar's family.

One of the most personal eggs, a gift from Nicholas to his wife Alexandra Feodorovna, was the Imperial Colonnade Egg, believed to celebrate the birth of the couple's only son and longed-for heir to the throne, the Czarevich Alexei. Another rather poignant theme is represented by the 1915 Imperial Red Cross Egg with Portraits, which Nicholas presented to his mother. At war with Germany, Russia had to mobilize all its resources, and the egg's surprise alludes to this fact: Czarina Alexandra Feodorovna, although exhausted from caring for her hemophiliac son, nevertheless gave her remaining energy to nursing the wounded; on a miniature screen, she and her four daughters are portrayed in their Red Cross uniforms.

Historical events are also commemorated in various eggs. In 1900, the opening of the Trans-Siberian Railway inspired the design of the Imperial Trans-Siberian Railway Egg, a miniature tribute to a truly momentous technological achievement that had impact across the continent. In 1912, the hundredth anniversary of Napoleon's defeat at the hands of the Russian army became the theme of the Imperial Napoleonic Egg. And in 1913, what should have been a joyous anniversary became, in hindsight, an ominous foreshadowing of the end of a dynasty: the Imperial Romanov Tercentenary Egg, which

celebrated 300 years of Romanov rule. Few people at the time could have predicted the violent end that was to befall the Romanovs just a few years later.

Though more illustrative of whimsy than theme, it is worth mentioning here that in a few eggs the design is such that the basic oval shape is almost, perhaps deliberately, disguised. In the Imperial Orange Tree Egg, for example, the crown of the tree, formed of individual carved nephrite leaves, is only minimally egg-shaped. And in the Imperial Uspensky Cathedral Egg, the top of the egg has been modified into the cross-topped onion-shaped dome so characteristic of Russian church architecture.

THE SURPRISES

To many people, the most intriguing aspect of Fabergé's eggs are the surprises; virtually every egg had at least one. Many of the eggs consisted of two halves, often hinged. When opened, the egg revealed its surprise: a miniature crown, a basket of flowers, a tiny hen, a little folding screen or easel. A surprise of this nature was completely removable—and irresistible—and perhaps for this reason, many of them were lost. Other eggs held surprises that were either incorporated into their shells or locked inside and thus meant to be viewed rather than actually handled. The Imperial Caucasus Egg, for example, had four miniature paintings on its enameled surface; each was concealed behind a hinged door that sprang open at the touch of a knob. The Imperial Cross of St. George Egg bore similarly hidden portraits.

Sometimes the surprise inside would pop up from the top of the egg when the appropriate knob or jewel was touched. The surprise might be a singing bird, as in the Imperial Cuckoo Egg, or a miniature portrait grouping, as in the Imperial Lilies-of-the-Valley Egg. Transparent rock-crystal eggs contained a miniature yacht (the Imperial Standart Egg), paintings (the Imperial Egg with Revolving Miniatures), or a replica of a statue (the Imperial Alexander III Equestrian Egg). A number of imperial eggs functioned as clocks; among these are the Imperial Madonna Lily Egg, the Imperial Cuckoo Egg, and the Imperial Colonnade Egg.

The most awe-inspiring surprises were the automata, those that could be made to move or to produce sounds by winding a mechanism with a tiny gold key. In the Imperial Trans-Siberian Railway Egg, the surprise was a movable seven-car railroad train. The Pine Cone Egg, commissioned by Alexander Kelch, contained an elephant that lumbered along naturalistically when wound up.

And the Imperial Uspensky Cathedral Egg contained a music box that played a hymn. The miniature imperial carriage inside the Imperial Coronation Egg, although not a true automaton since it had no wind-up mechanism, was nevertheless fully articulated and could be rolled along on its platinum-rimmed gold wheels. One can imagine the cries of delight and amazement that must have greeted these treasures.

ORGANIZATION OF
THIS BOOK

The eggs are arranged in chronological order; however, one can browse at random. Each egg is given a page to itself, with accompanying text on the facing page. Occasionally a surprise or close-up is given on a separate page; this will be found immediately following the egg to which it belongs. The commentary gives the name of the egg, the year (when known), the workmaster (when known), the dimensions, and the current ownership.

Fabergé Eggs

FIRST IMPERIAL EGG
1885

Workmaster Erik Kollin (?), St. Petersburg.
Height 2½" (6.4 cm); diameter of yolk 1⁹⁄₁₆" (4 cm); length of hen 1³⁄₈" (3.5 cm).
The Forbes Magazine Collection, New York.

It is fitting that the First Imperial Egg should, at least at first glance, so resemble a real hen's egg. There would be plenty of occasion for flights of fancy in the design of subsequent eggs, but perhaps in this case Fabergé was "testing the waters." This egg, presented by Czar Alexander III to his wife Marie Feodorovna, is a simple one, not much larger than life size, and it is finished in plain, white matte enamel. The exterior is uncharacteristically free of embellishment. Once opened, however, the egg reveals the imagination and genius of its creator.

The inside of the shell is lined in gold and cradles a golden yolk. The yolk opens to display a tiny hen with ruby eyes and delicately modeled feathers in four shades of gold, sitting on a nest of golden straw. The hen, like the egg, is hinged and can be opened. Originally, the hen contained a replica of the imperial crown, with an egg-shaped ruby suspended from it. This surprise is now lost.

This First Imperial Egg is similar to, and may have been inspired by, a French ivory egg owned by Marie Feodorovna's father, King Christian IX of Denmark. In 1898 Fabergé created a much fancier version of the hen egg for Alexander Ferdinandovich Kelch, the mining magnate, who presented it to his wife, Barbara (née Bazanov).

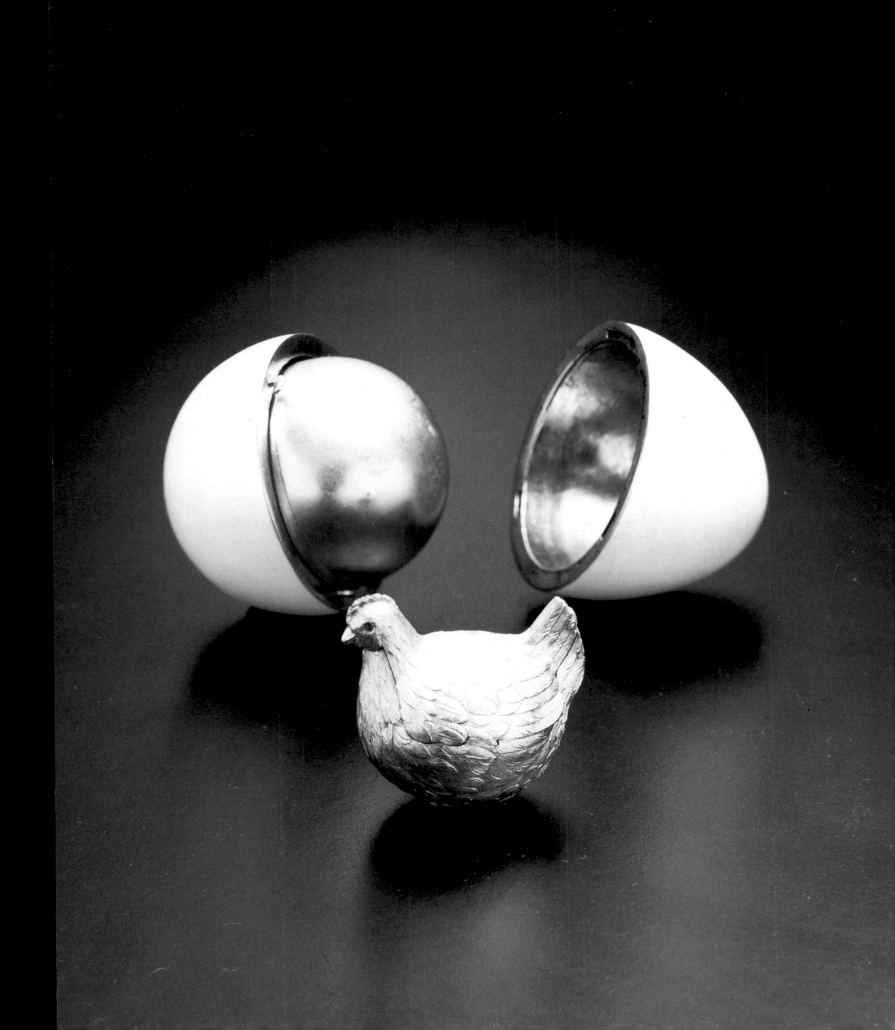

IMPERIAL RESURRECTION EGG
1889

Workmaster Michael Perchin, St. Petersburg. Height 3⅞" (9.8 cm).
The Forbes *Magazine Collection, New York.*

Here is the last egg ordered by Alexander III as a gift to Marie Feodo-rovna, for the Czar died in November 1894, eight months after presenting it. It is based on a very similar eighteenth-century egg casket by LeRoy in the Grünes Gewölbe (Green Vaults) in Dresden, which Fabergé would have seen when he was a student in that city.

Crafted of translucent, milky white agate with gold fittings, the Im-perial Renaissance Egg is a dazzling example of the jeweler's art. The egg lies on its side and opens lengthwise. On the top half, the surface is crisscrossed by white enamel trelliswork, each intersection set off by four rose diamonds and a cabochon ruby mounted in gold. An oval plaque of transparent red enamel, rimmed in diamonds, is situated at the center top; it bears the date 1894 in rose diamonds. Surrounding the plaque is a scalloped border delineated by more diamonds and garnished with enameled and jeweled motifs of various shapes. Variations of these mo-tifs, along with white and gold swirls, are applied around the lower part of the top half, just above the opening edge.

The bottom half of the egg is visually separated from the top half by a narrow band of red enamel over a *guilloché* ground, set at regular in-tervals with rosette-mounted diamonds. A total of six fan-shaped motifs, enameled in blue, green, and white over gold, decorates the bottom half of the egg; the one at center front serves as a clasp. Cradling the egg is a gold base patterned with palmettes and flowers or husks in translucent green and red, all on a background of shimmering opaque white enamel. As a finishing touch, each end of the egg is mounted with a gold lion's head holding a free-swinging ring handle in its mouth.

ERRATA

THE CORRECT DESCRIPTION FOR PAGE 18 IS THE FOLLOWING:

IMPERIAL RESURRECTION EGG
1889

Workmaster Michael Perchin, St. Petersburg. Height 3⅞" (9.8 cm).
The Forbes *Magazine Collection, New York.*

Another gift from Czar Alexander III to Czarina Marie Feodorovna, the Imperial Resurrection Egg is one of the few imperial eggs to be based on a dominantly religious theme. (Although a few other eggs displayed crosses, these were simply part of the design and were not necessarily intended to convey a religious message.) Generally thought to be the second egg presented by the Czar to his wife, the Imperial Resurrection Egg is carved out of clear rock crystal and mounted in gold. Within its highly polished, transparent shell is a scene of the risen Christ standing atop his tomb, with two angels kneeling in wonder at his feet. The figures, realistically sculpted and detailed, are enameled in lifelike colors and rest on an enameled base circled by pearls and diamonds.

The gold quatrefoil stand is lavishly decorated in Renaissance style. Each of its four panels is covered in swirls of translucent red, blue, and green enamel. The panels are outlined by narrow bands of opaque white enamel punctuated at regular intervals by tiny red dots, and are separated by cascades of graduated rose diamonds. Four pearls nestle near the base, one in each panel.

The stand rises to a peak that culminates in a horizontal band of brilliant cut diamonds set into a background of black and white enamel. It is topped with a large, gold-mounted pearl. Just above the pearl is the diamond-encrusted support of the crystal egg.

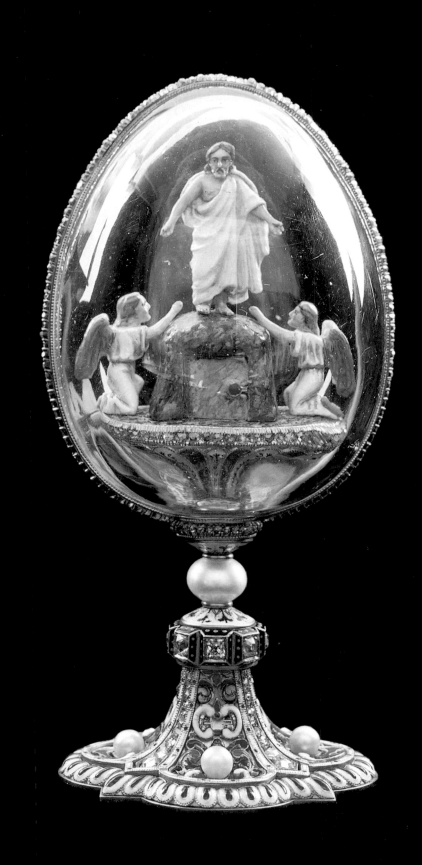

IMPERIAL BLUE ENAMEL RIBBED EGG
BEFORE 1899

Workmaster Michael Perchin, St. Petersburg. Height 4⁵/₁₆" (II cm).
Private collection.

This elegant blue and gold egg may have been a gift from Czar Alexander
III to his wife, Marie Feodorovna. Translucent blue enamel over a *guil-
loché* ground in a gentle wave pattern forms the base for the decorative
gold overlay. The egg rests on a swirled gold pedestal that fans out into
a cuplike formation of acanthus leaves. Around the middle section of the
egg, fine vertical bands of gold worked in two alternating patterns create
the ribbed effect that gives the egg its name. Between the ribs, the enamel
work can be seen. It is the understated classicism of this motif that makes
it at once striking and appealing.

The dome-shaped upper portion of the egg is enhanced by a gracefully
draped cap of solid, but not heavy, golden loops alternating with flowers
facing downward on slender stems. These highly stylized floral forms,
with their delicate, feathery petals, could be lilies-of-the-valley or just
another manifestation of Fabergé's imagination.

Sitting atop all this splendor, on a small chased-gold pedestal of its
own, is an imperial crown of gold, set with faceted sapphires and dia-
monds. The sparkling blue of the sapphires creates a perfect complement
to the rich blue of the enameling.

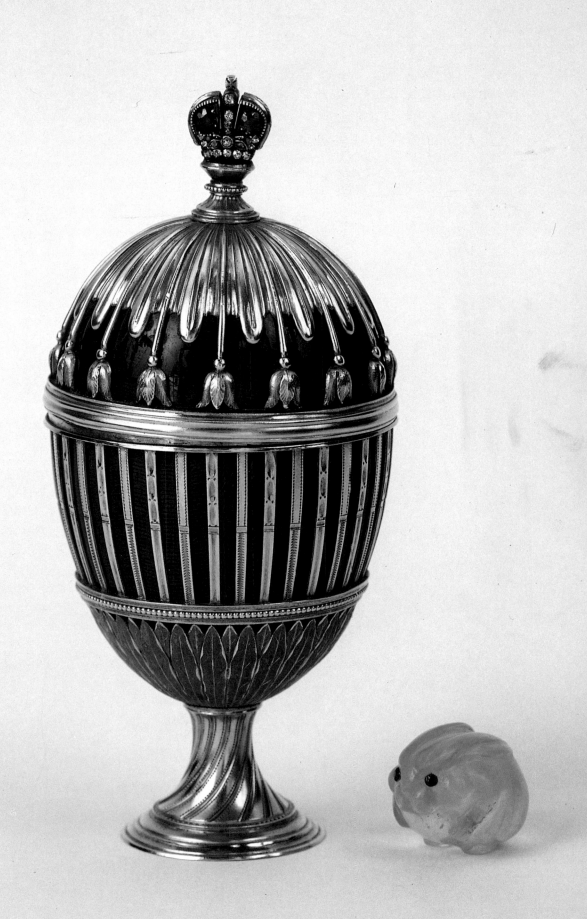

IMPERIAL SPRING FLOWERS EGG

(IN ORIGINAL CASE)

1891–1899

Workmaster Michael Perchin, St. Petersburg.
Height of case 5⅜" (13.7 cm.); height of egg 3¼" (8.3 cm); height of basket 1½" (3.8 cm).
The Forbes *Magazine Collection, New York.*

Another gift from Czar Alexander III to Marie Feodorovna, the Imperial Spring Flowers Egg represents three treasures in one: the case, the egg, and the surprise.

The original presentation case is itself a work of art, as are the few others, made for other eggs, that have survived. Appropriately, the case is egg-shaped. It is constructed of white maple and is covered in fine velvet the color of ripened wheat. The bottom of the case is slightly flattened to serve as a stable base. Unfastening the three clasps allows the case to be opened, and the front section can then be let down by means of a fabric hinge to reveal the interior.

The inside of the case is lined in creamy satin, its soft, draped folds creating a cozy nest as well as a contrasting backdrop for the treasure it houses. The lining of the front section is stamped in gold with an imperial eagle and the words, in Russian, "Fabergé/St. Petersburg/Moscow/London"—a forgivably proud statement reflecting the heyday of the house of Fabergé. Set into the base is a low, round pedestal covered in velvet to match the outer covering. It is on this pedestal that the Imperial Spring Flowers Egg stands, ready to be viewed and marveled at.

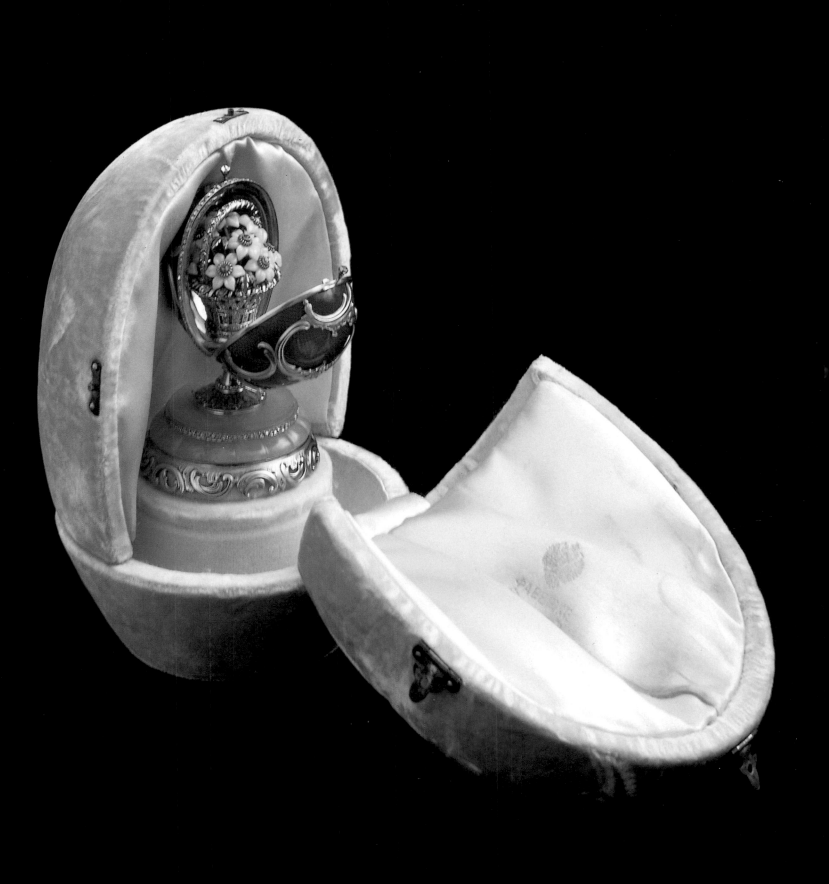

IMPERIAL SPRING FLOWERS EGG

(OPENED)

Gold, platinum, diamonds, semiprecious stones, and jewel-like translucent enamel are combined here to create an exquisite egg and a breathtaking surprise.

The egg, on a stem of chased gold, is enameled in transparent red over a *guilloché* ground. Closed, the edges of the two halves are hidden by a band of red gold embedded with rose diamonds all around. The egg opens longitudinally by means of a double-pronged clasp, similar to the type found on a change purse, also set with rose diamonds. A cage of rococo-style scrollwork in green gold is applied to both halves of the egg. More golden scrollwork is found on the base, a carved and stepped affair of bowenite, encircled by a similar band of diamond-studded gold.

Inside the gold-lined egg is the surprise, the basket of spring flowers. A bouquet of wood anemones invokes the first breath of spring for anyone lucky enough to view it. Each six-petaled blossom is fashioned of white chalcedony and is centered with a green demantoid garnet in a fluted setting. Green-enameled gold stems and leaves complete the ensemble.

The design of the open-work basket, made of diamond-encrusted platinum, is reminiscent of the pointed arches so characteristic of Gothic cathedrals—here, a minutely scaled-down version of a massive architectural element. Every surface of the basket is embellished: the rim is carved and set with diamonds, and the handle is worked in a spiral design. The basket can be lifted off the little golden table on which it rests.

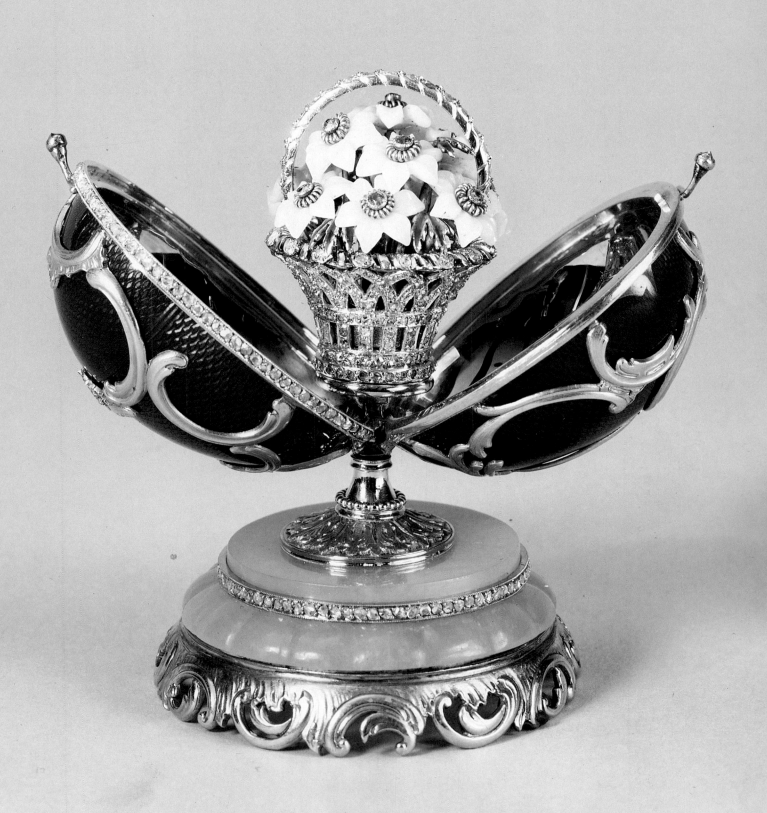

IMPERIAL *PAMIAT AZOVA* EGG
1891

Workmaster Michael Perchin, St. Petersburg. Height 3⅞" (9.8 cm).
The Armory Museum, Moscow.

Before he became Czar in 1894, as heir to the throne Nicholas made a voyage around the world from 1890 to 1891, aboard the cruiser *Pamiat Azova*. He took the trip at the urging of his parents, Alexander III and Marie Feodorovna, who hoped it would augment his education, broaden his horizons, and create a favorable diplomatic atmosphere. Nicholas was accompanied by his younger brother, the Grand Duke George. It is to commemorate this voyage that the Imperial *Pamiat Azova* Egg was created.

Crafted of rich, dark green jasper veined and flecked with red and blue, the Imperial *Pamiat Azova* Egg is decorated with a generous overlay of rococo scrollwork in gold, much of it set with diamonds. The free-flowing design is somewhat abstract but incorporates naturalistic elements such as leaves, plumes, and flowers. The clasp, part of a carved gold band that circles the egg, is set with a large ruby flanked by diamonds and platinum scrolls.

The egg opens horizontally into two asymmetrical halves to accommodate the surprise within. This is a model of the *Pamiat Azova* and comes from the workshop of August Hollming, one of several Finnish workmasters in Fabergé's employ. The little ship, which appears to float upon a tranquil sea of aquamarine, is minutely and authentically detailed in gold and platinum. It has masts, rigging, smokestacks, lifeboats, an anchor chain, ladders, and even, since it *is* a battleship, guns. It is an amazing piece of work.

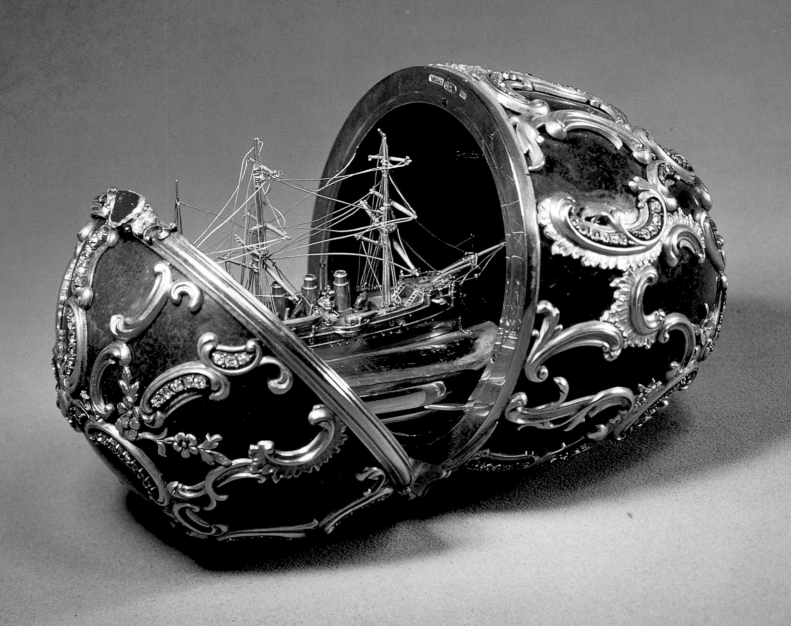

IMPERIAL CAUCASUS EGG
1893

Workmaster Michael Perchin, St. Petersburg. Height 3⅝" (9.2 cm).
The Matilda Geddings Gray Foundation,
on loan to the New Orleans Museum of Art.

The Imperial Caucasus Egg takes its name from the imperial mountain retreat at Abastouman in the Caucasus. Done in the Louis XV style, the egg has a gold shell that is machine-turned in a basket-weave pattern and enameled in translucent red. Elaborate swags of flowers and leaves in four-color gold suspended from platinum bows, all encrusted with rose diamonds, festoon the egg. There are four oval doors around the egg, each bearing one diamond-studded and laurel-wreathed numeral of the year 1893. Edged in pearls, each door swings open on jeweled hinges with pearl finials to reveal a miniature painting, executed by K. Krijitski, of a scene at the imperial retreat. The inside of each door, polished to mirror brightness, is embellished as well, with a gold laurel wreath.

Ironically, this extraordinarily rich and beautiful egg carries with it a hint of misfortune for the imperial family. Grand Duke George Alexandrovich, the younger brother of Czar Nicholas II, was forced to spend most of his time at the mountain retreat because he was afflicted with lung disease; it was hoped that the high altitude would be beneficial to his health. But, he was beyond help and died of tuberculosis in 1899 at the age of twenty-eight. A hidden portrait of the Grand Duke can be seen by holding the egg end up to a light and looking through the large table diamonds at either end.

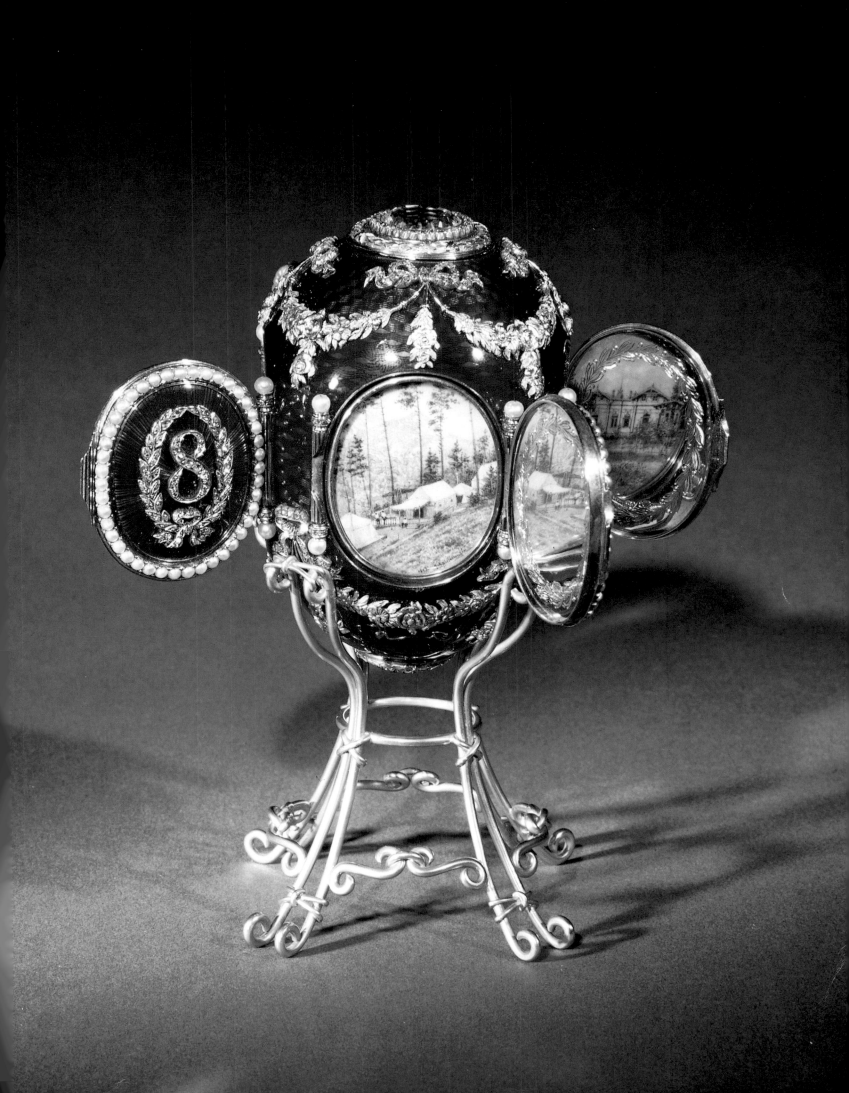

IMPERIAL RENAISSANCE EGG
1894

Workmaster Michael Perchin, St. Petersburg. Length 5 ¼" (13.3 cm).
The Forbes *Magazine Collection, New York.*

Here is the last egg ordered by Alexander III as a gift to Marie Feodo-rovna, for the Czar died in November 1894, eight months after presenting it. It is based on a very similar eighteenth-century egg casket by LeRoy in the Grünes Gewölbe (Green Vaults) in Dresden, which Fabergé would have seen when he was a student in that city.

Crafted of translucent, milky white agate with gold fittings, the Imperial Renaissance Egg is a dazzling example of the jeweler's art. The egg lies on its side and opens lengthwise. On the top half, the surface is crisscrossed by white enamel trelliswork, each intersection set off by four rose diamonds and a cabochon ruby mounted in gold. An oval plaque of transparent red enamel, rimmed in diamonds, is situated at the center top; it bears the date 1894 in rose diamonds. Surrounding the plaque is a scalloped border delineated by more diamonds and garnished with enameled and jeweled motifs of various shapes. Variations of these motifs, along with white and gold swirls, are applied around the lower part of the top half, just above the opening edge.

The bottom half of the egg is visually separated from the top half by a narrow band of red enamel over a *guilloché* ground, set at regular intervals with rosette-mounted diamonds. A total of six fan-shaped motifs, enameled in blue, green, and white over gold, decorates the bottom half of the egg; the one at center front serves as a clasp. Cradling the egg is a gold base patterned with palmettes and flowers or husks in translucent green and red, all on a background of shimmering opaque white enamel. As a finishing touch, each end of the egg is mounted with a gold lion's head holding a free-swinging ring handle in its mouth.

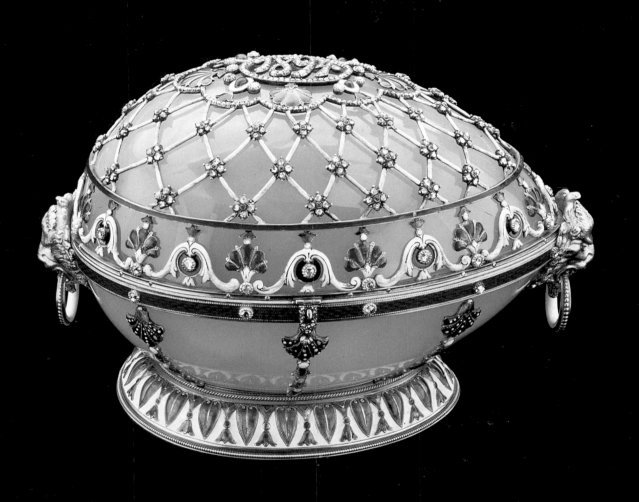

IMPERIAL RENAISSANCE EGG

(OPENED)

Even in the egg's interior, the artistry of Fabergé is strikingly apparent. The agate shell, smooth and polished to a pearly sheen, is so thin and translucent that the shadows of the trelliswork and other ornamentation on the outer surface are easily visible from the inside. Everything is beautifully finished: the surfaces are flawless, and there are no rough edges nor traces of construction. In effect, there is no wrong side. Notice, too, the abutting edges of the top and bottom halves: Enameled in pristine white and outlined in gold, they are adorned with a delicate golden tracery, in a repeating design of flowers, leaves, and curling vines. Even the inside of the hinge bears a little bit of this same decoration.

If this egg, like most other imperial eggs, contained a surprise, its nature and whereabouts are unknown. There is speculation that the surprise could have been a jewel, but that is only conjecture. Since so many of the surprises were free-standing or independent, it is no wonder that so many were lost. The temptation to hold or fondle them, or to display them elsewhere, must have been too great to resist.

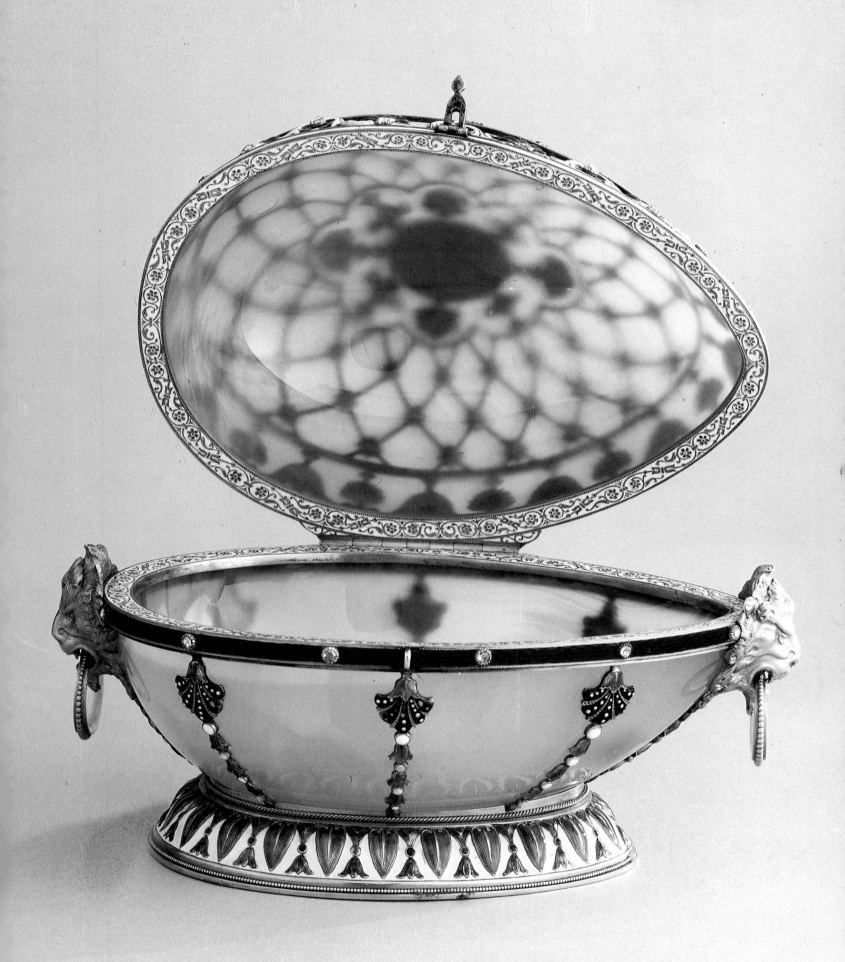

IMPERIAL ROSEBUD EGG
1895

Workmaster Michael Perchin, St. Petersburg.
Height 3" (7.6 cm); length of rosebud 1³⁄₁₆" (3 cm).
The Forbes *Magazine Collection, New York.*

After the death of Alexander III, his son Czar Nicholas II carried on the tradition of giving a jeweled Easter egg to the Czarina, his wife Alexandra Feodorovna. (He also continued to present an egg each year to his mother, the Dowager Empress Marie Feodorovna.) The Imperial Rosebud Egg is the first egg to be given by the new Czar, and it takes its name from the surprise found inside.

Rows of diamonds divide the egg into panels, four each on the top and bottom sections. The two sections are separated by a similar, horizontal band of diamonds edged with white enamel on gold. The background of the egg is translucent red enamel over a wave-patterned, machine-turned ground. Each panel of the top portion has a sculptured gold laurel wreath standing out in strong relief, with a flowing, diamond-studded ribbon "knotted" to it. At the very top of the egg is a miniature portrait of Nicholas, covered by a large, flat table diamond and framed in gold.

The golden laurel is also used on the bottom portion of the egg, where it is fashioned into more wreaths and swags, the latter suspended from small, rosette-set diamonds. A slender gold arrow, tipped and feathered in diamonds, bisects each panel. Although it is comparatively sparse and restrained in embellishment, the elements are so well integrated that the Imperial Rosebud Egg nevertheless makes an impression of great elegance.

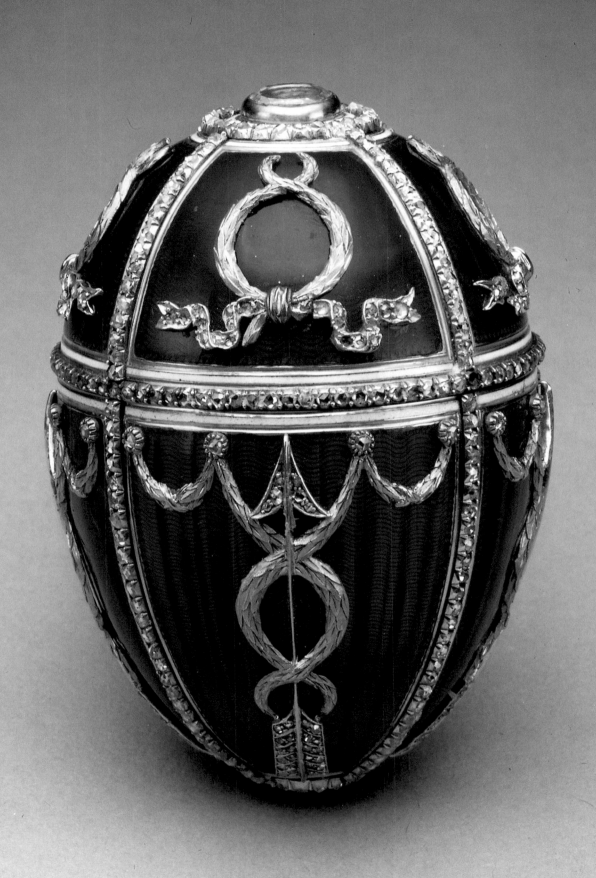

IMPERIAL ROSEBUD EGG

(OPENED)

The interior of the Imperial Rosebud Egg is lined in velvet to serve as a cushioned case for the surprise, a rosebud. A creamy off-white, the velvet lining is shaped to fill both the top and bottom halves of the egg. By looking closely, it is possible to see the seam where the upper lining joins a small circular section that fits up against the inside top of the egg. Also visible, on the inner rim of the bottom section, are the markings stamped into the gold. The one on the left reads "Fabergé" in Russian.

The rosebud surprise is naturalistically modeled from life, with separate petals of yellow, and a calyx, sepals, and short stem in green. All these parts are shaded and textured to resemble an actual blossom. Except for a small gold hinge, the entire rosebud is enameled, with a matte finish, and it looks as though it might have been freshly plucked from the bush.

An additional surprise, a miniature imperial crown with a ruby egg pendant, is known to have been included inside the rosebud. However, like the very similar surprise found inside the hen of the First Imperial Egg, this one has also disappeared.

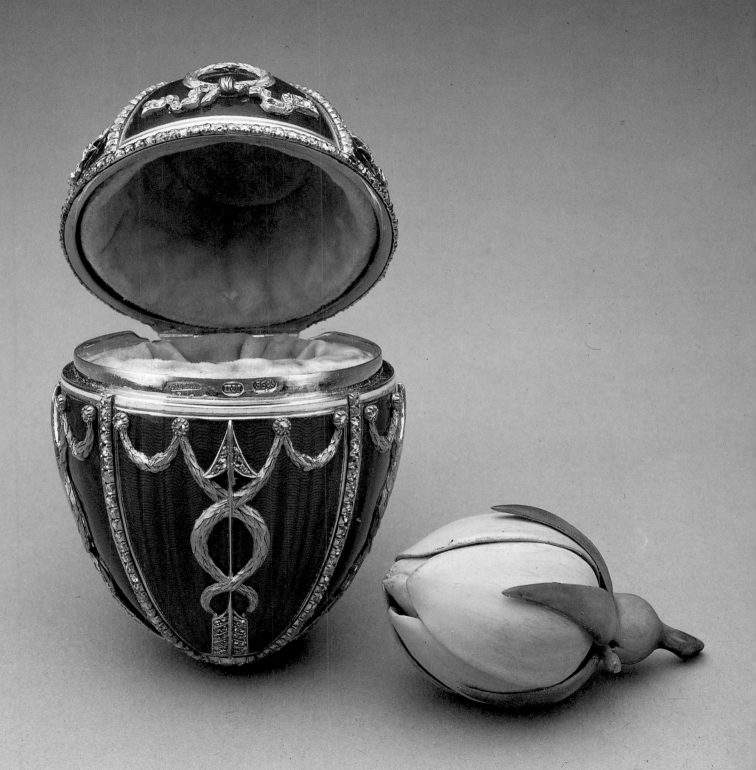

IMPERIAL DANISH PALACE EGG
1895

Workmaster Michael Perchin, St. Petersburg. Height 4" (10.2 cm).
The Matilda Geddings Gray Foundation,
on loan to the New Orleans Museum of Art.

The Imperial Danish Palace Egg was a gift from Czar Nicholas II to his mother, the Dowager Empress Marie Feodorovna. The egg itself is enameled in opalescent pink over a *guilloché* ground worked in an all-over pattern of small, four-pointed stars. It is divided into panels by bands of gold elaborately chased in a palm-leaf design and set with rows of diamonds, with a single cabochon emerald at each intersection. The egg wears a cap of chased gold and diamonds, surmounted by a shimmering star sapphire. In its symmetry and simplicity, the design creates an impression of elegant dignity.

The egg's surprise is a miniature screen comprising ten hinged panels, each framed and footed in gold with intricate chased designs, including a garland of flowers and leaves along the gently arched top. The panels, of mother-of-pearl, were painted in 1891 by Krijitski, who also painted the scenes of the Imperial Caucasus Egg. With its pearly backgrounds and delicate coloring, the screen is a perfect companion piece to the iridescent pink egg. Meticulously detailed, the panels picture the various palaces and residences of the Danish royal family, along with two imperial yachts. The Dowager Empress, who was a Danish princess (named Dagmar) before her marriage to Alexander III, must surely have felt a twinge of nostalgia at the sight of these lovely miniature vistas.

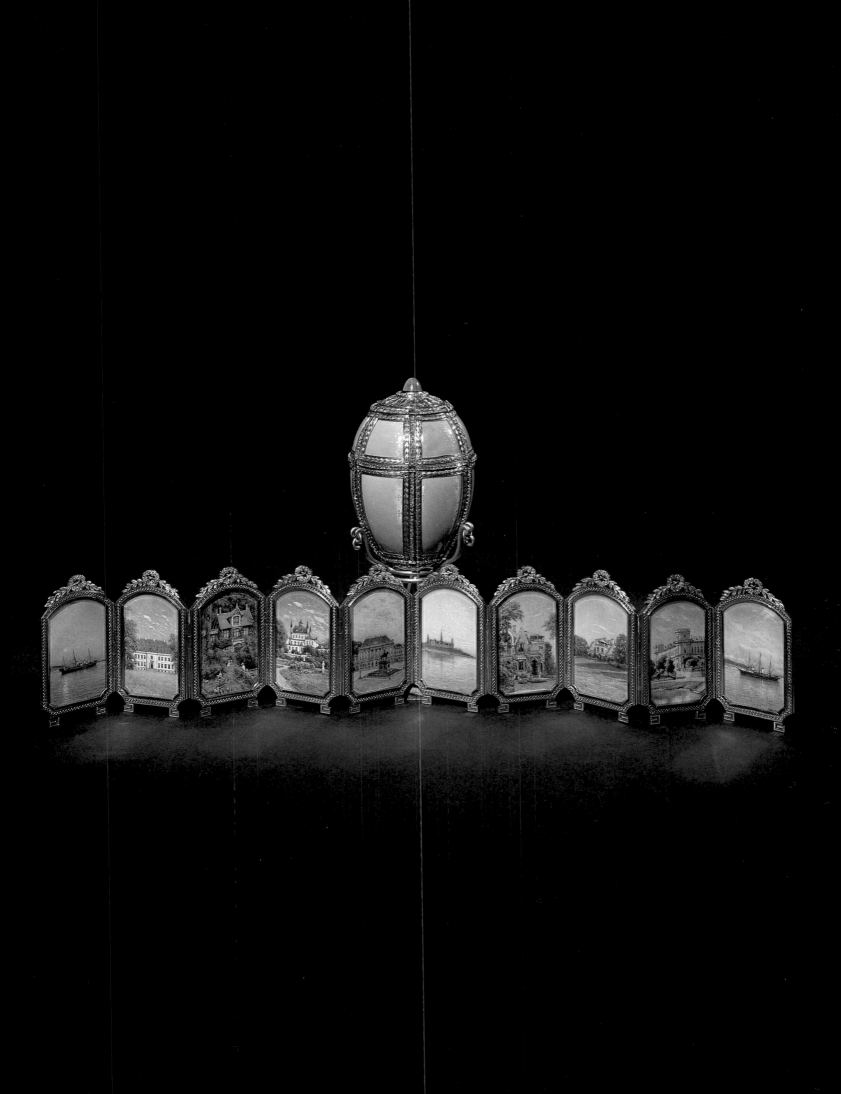

IMPERIAL MONOGRAM EGG
BEFORE 1896

*Workmaster Michael Perchin, St. Petersburg. Height 3¼" (8.3 cm).
Courtesy of Hillwood Museum.*

It is thought that the Imperial Monogram Egg may have been presented by Czar Alexander III to his wife Marie Feodorovna to mark their twenty-fifth wedding anniversary in 1892. Whatever the truth of the matter, the egg is certainly a worthy gift for such a special occasion. The marriage of the Danish princess to the heir to the Russian throne was not only an alliance of two royal houses, it was also a union of two individuals, and the design of the Imperial Monogram Egg reflects that union.

Each half of the egg, which opens horizontally, is divided into six panels by rows of rose-cut diamonds, subtly graduated in size. Separating the two halves is a band of diamonds that circles the egg, accented by a diamond in a square mounting at each intersection. The background of the panels is a luminous blue enamel on a *guilloché* ground, overlaid with delicate scrollwork in reddish gold. The imperial monograms of rose-cut diamonds, in Cyrillic letters, appear in each panel: "A III" in the lower-half panels, "MF" in the upper. Each monogram is capped by a tiny imperial crown set with diamonds. At the top and bottom of the egg, there is a large table diamond surrounded by a circle of small, rose-cut diamonds.

The inside of the egg, lined in red velvet, once held a surprise, which is now lost.

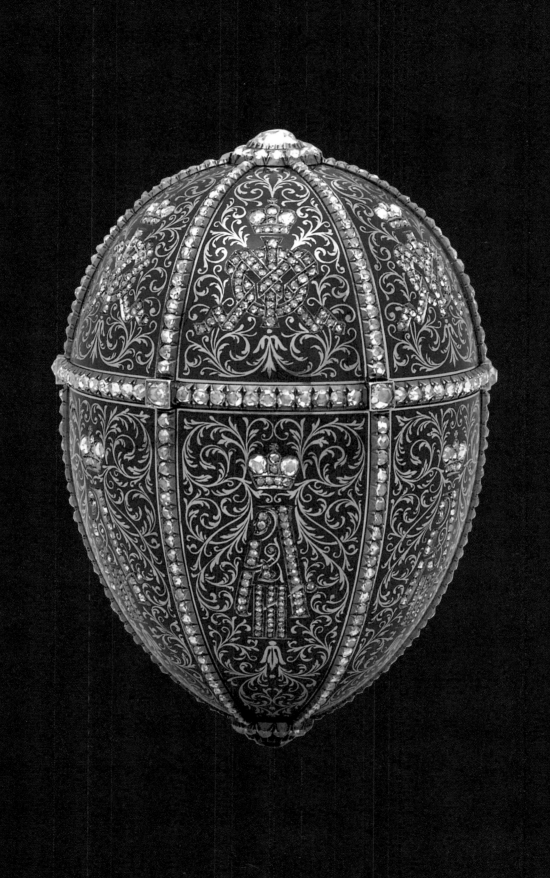

IMPERIAL EGG
WITH REVOLVING MINIATURES
ca. 1896

Workmaster Michael Perchin, St. Petersburg. Height 10″ (25.4 cm).
Virginia Museum of Fine Arts, Richmond.
Bequest from the Estate of Lillian Thomas Pratt, 1947.

The imperial eggs vary considerably in shape; some are almost round, while others are more elongated, like an actual egg, which tends to be rounded at one end and somewhat narrowed at the other. Many of the imperial eggs are nearly true ovals, with both ends almost equal in shape. The Imperial Egg with Revolving Miniatures, however, is shaped more like a natural egg, and unlike many of the other truly egg-shaped examples, it is positioned with the narrowed end uppermost. It is also one of the largest of the imperial eggs, the integrated stand contributing substantially to the overall height.

The shell is made of clear rock crystal bisected longitudinally by a gold band set with rose diamonds. It houses a ribbed gold column to which are attached five miniature, gold-framed paintings. These depict some of the royal residences of Czarina Alexandra Feodorovna, who was given this egg by her husband Nicholas II. Atop the column, on the outside of the egg, sits a large, conical, cabochon-cut Siberian emerald, mounted in a small, plumed cup of gold. The column can be rotated so as to facilitate the viewing of the miniature art exhibition within.

The design of the stand, done in champlevé enamel on gold, incorporates the monogram of Alexandra, both in her native German and adopted Russian, with diamond-studded crown motifs topping the monograms. The stand rests on a circular stepped base of clear rock crystal, through which the turning mechanism of the central column is easily visible.

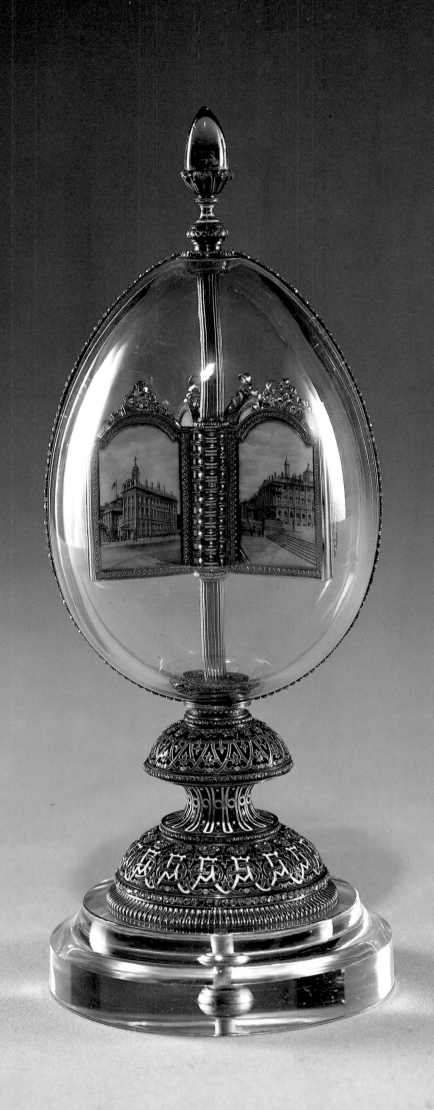

IMPERIAL CORONATION EGG
1897

Workmasters Michael Perchin and Henrik Wigström, St. Petersburg.
Height of egg 5" (12.7 cm); length of coach 3¹¹/₁₆" (9.3 cm).
The Forbes *Magazine Collection, New York.*

The Imperial Coronation Egg, with its surprise—a miniature imperial carriage—is surely the epitome of the goldsmith's art. Presented by Czar Nicholas II to the Czarina Alexandra Feodorovna at Easter 1897, it commemorates their coronation in 1896.

The surprise, less than four inches long, is an exact replica of the coronation coach used by the Czar and his wife. It took the craftsman, George Stein, a former coachmaker, fifteen months to complete this tiny masterpiece as he painstakingly reproduced the exact design and colors of the original. The frame is of chased gold, the windows of etched rock crystal. Hinged doors open to reveal the interior, done in enamels to represent the colors of the actual coach: the ceiling in turquoise, the curtains in powder blue, and the upholstery in the same strawberry-red as the original velvet. On the ceiling can be seen the hook from which a diamond-studded egg, now lost, once dangled. At the doorway, a set of steps drops down from the inside.

The exterior of the coach, whose body and driver's seat are enameled in red, is decorated with gold trelliswork punctuated by diamonds; the doors carry the imperial crest in gold and diamonds. On the roof of the coach is an imperial crown of diamonds borne on a cushion of red enamel with a gold tassel at each corner. The edges of the roof are further embellished by golden imperial eagles, their wings spread in readiness for flight. The entire carriage is fully articulated; the gold wheels, rimmed in platinum, rotate on their axles and can make turns.

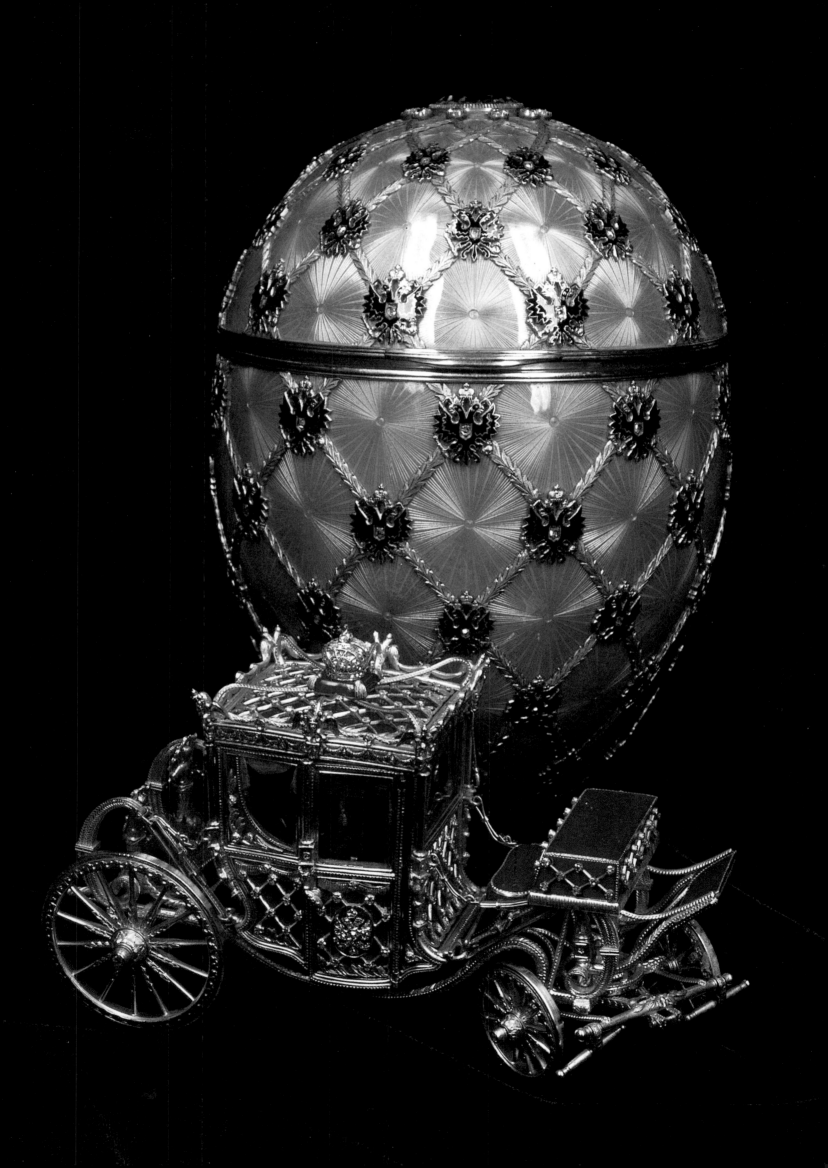

IMPERIAL CORONATION EGG

(DETAIL)

Over a *guilloché* ground of ribbed sunbursts, a sharp yellow translucent enamel coating has been applied to the egg. This glassy surface serves not only as a backdrop, but also as a contrast, to a trelliswork design of incised laurel leaves which have been given a fine, pebbly texture. At each crossing point there is an imperial two-headed eagle motif in black enamel and red gold, with a single diamond set into a tiny shield at its center. A close look discloses an interesting touch of deep blue enamel near the top of each motif. Both of the eagle's heads are crowned, and a third, larger crown is centered at the top of the motif. The eagle clutches the symbols of imperial power in its talons—an orb on one side and a scepter on the other.

The top and bottom portions of the egg—the bottom being considerably deeper—are separated by simple red gold rings and an unadorned clasp. At the very top of the egg, the Czarina's initials—"AF" in Cyrillic letters—in diamonds and red enamel are visible through a table-cut diamond.

When opened, the egg reveals a fitted, off-white velvet lining for the wonderful miniature coach surprise.

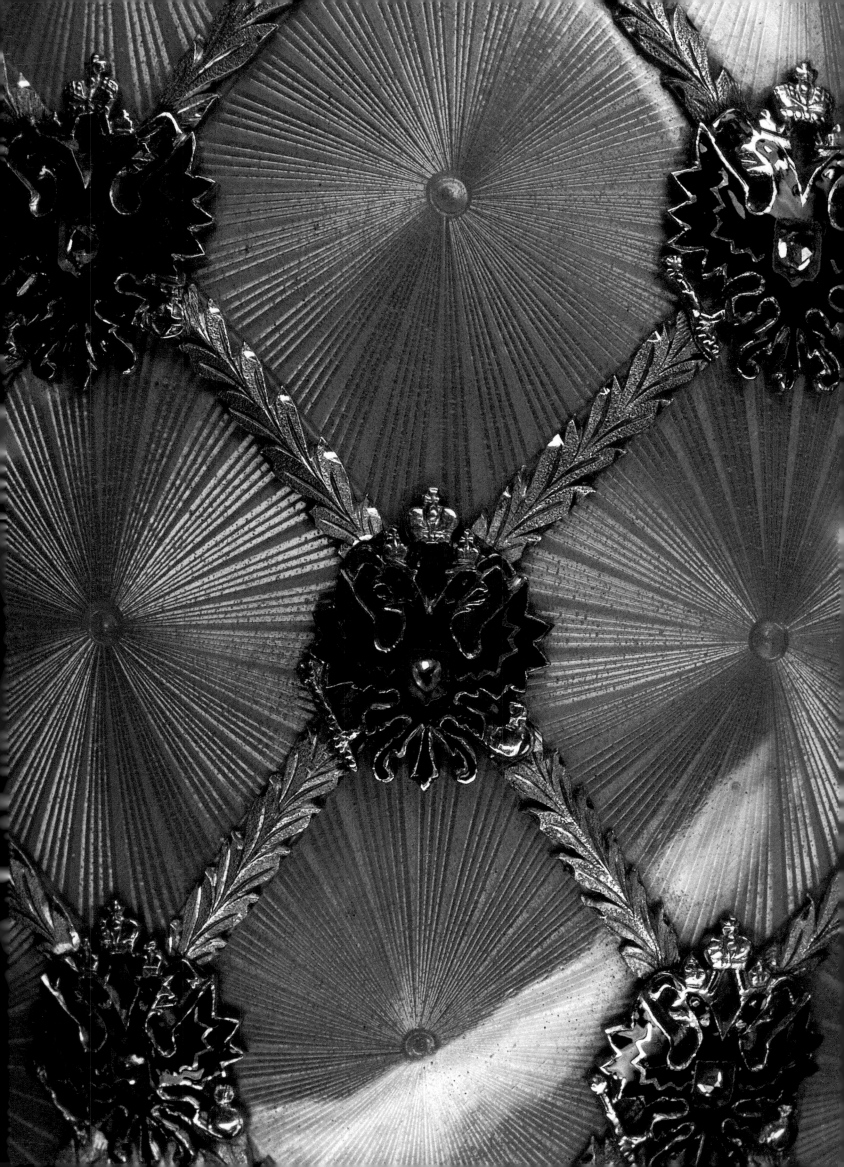

IMPERIAL PELICAN EGG
1897

Workmaster Michael Perchin, St. Petersburg. Height 4" (10.2 cm).
Virginia Museum of Fine Arts, Richmond.
Bequest from the Estate of Lillian Thomas Pratt, 1947.

This rather formidable egg, with its shell of solid gold, has a somewhat martial air, but it is softened by the presence of a bejeweled pelican at its top. The egg was given to the Dowager Empress Marie Feodorovna by her son Czar Nicholas II. When the egg is removed from its stand and opened, it becomes a folding screen consisting of eight miniature paintings.

Unlike so many other imperial eggs, the Imperial Pelican Egg is devoid of jewels, except for those used for the pelican. The reddish-gold shell is incised with garlands, boughs, and wreaths of laurel, as well as a prominent imperial eagle. Stars, stylized flowers, and flowing ribbons contribute to the overall design. A longitudinal band bears the inscription "Visit our vineyards, O Lord, and we shall live in Thee."

A symbol of motherly love, the pelican, of gold, enamel, and diamonds, hovers over her young, who appear to be clamoring for attention and food. All are housed in a nest of golden twigs. Perhaps the theme of the nurturing pelican was also intended as a token of appreciation for the Dowager Empress.

The egg itself is displayed in an elaborately chased stand of gold, on which a rather fierce-looking, crowned eagle's head tops each of four legs terminating in claw feet. The open spaces between the legs are diagonally crossed by arrows with golden rosettes at the intersections.

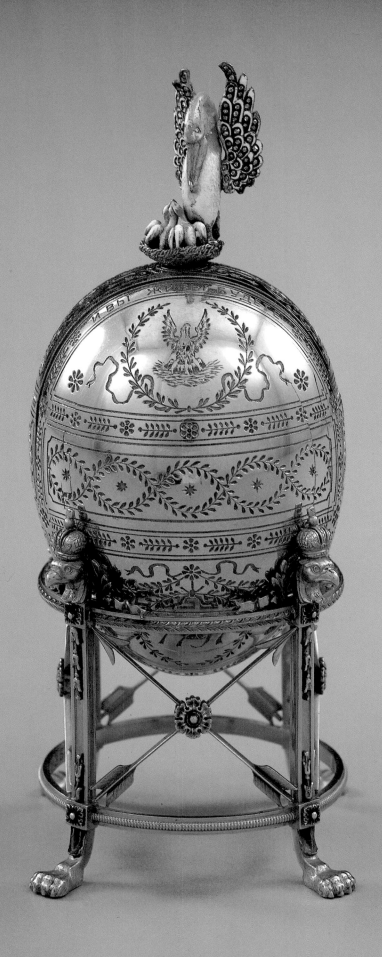

IMPERIAL PELICAN EGG

(OPENED)

So precise is the craftsmanship that went into the Imperial Pelican Egg that one must look very carefully to detect the seams where the sections of this egg meet. However, the egg does have seams and does open—into eight hinged panels, each one representing a vertical cross-section of the egg. The pelican, poised atop a slender golden pole, is at the center when the screen is fully extended.

The panels bear ivory miniatures, each surrounded by a border of seed pearls and a frame of chased gold. They were painted by Johannes Zehngraf, and they depict the institutions of the Empress Marie, the wife of Czar Paul I. These institutions were founded by the Empress in 1797 for the purpose of educating girls of the nobility, and they were still in operation 100 years later when the Imperial Pelican Egg was presented; hence the dates, 1797–1897, that are engraved on the outside of the egg. In fact, the government department that controlled and administered the institutions endured right up to the end of the Czarist era.

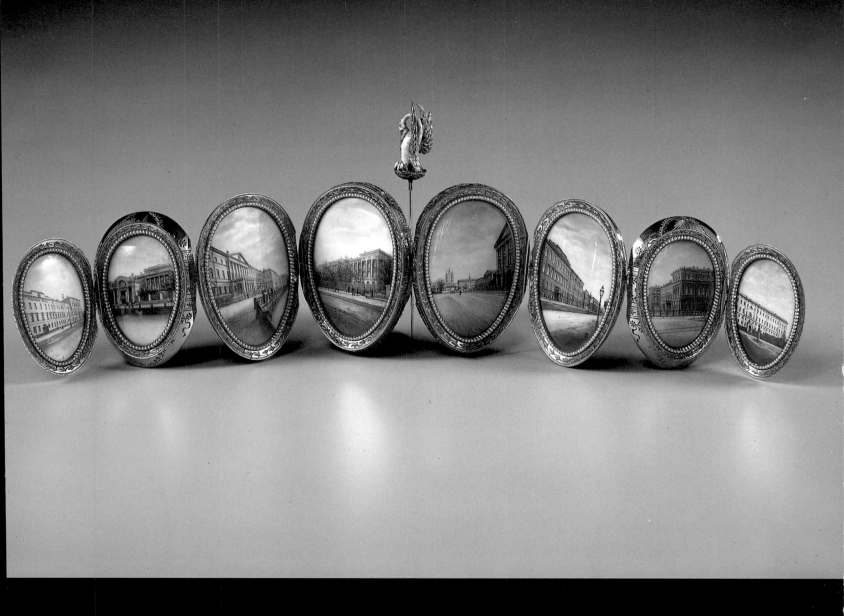

KELCH HEN EGG
1898

Workmaster Michael Perchin, St. Petersburg.
Length of egg 3¼" (8.3 cm); length of hen 3⅜" (8.6 cm); height of easel 1⅞" (4.8 cm).
The Forbes Magazine Collection, New York.

It is interesting to compare this egg, presented in 1898, with the First Imperial Egg of 1885, on which it is obviously based. Like its predecessor, the Kelch Hen Egg contains a yolk which opens to reveal a small hen. However, whereas the First Imperial Egg opens crosswise and is enameled in matte white to resemble an actual hen's egg, the slightly larger Kelch Hen Egg is enameled in translucent strawberry-red over a basket-weave *guilloché* ground and opens lengthwise, the opening being bordered by a band of diamonds. An octagonal clasp is marked with the date.

The imperial egg hen surprise is made of four-color gold textured to resemble feathers; the Kelch hen is enameled in a shiny, mottled design suggesting brown feathers. Its eyes are diamonds as opposed to the imperial egg's rubies. Both hens served as containers for additional surprises: the imperial one—a tiny crown with a ruby pendant—is lost, but the Kelch surprise survives. It is a diamond-studded easel now bearing a portrait of Czarevich Alexei. The portrait must have been added later, since he was not born until 1904. The legs of the gold easel are hinged to allow the surprise to fit inside the hen.

This egg was one of a series presented by Alexander F. Kelch, a Siberian mining executive, to his wife, Barbara. Although it was not imperial in ownership, the Kelch Hen Egg is unquestionably imperial in quality, and can rightfully claim a place in any collection of Fabergé eggs.

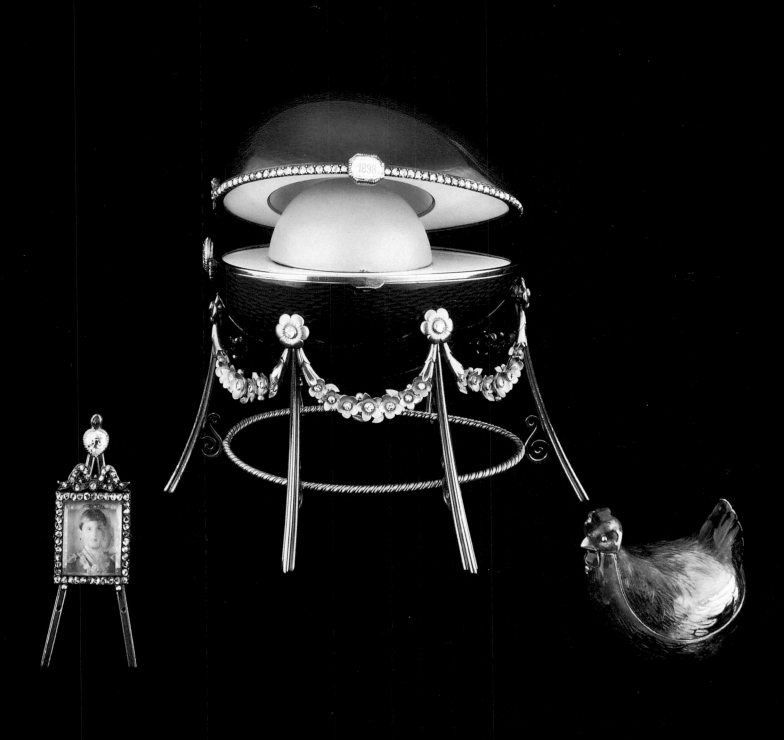

IMPERIAL LILIES-OF-THE-VALLEY EGG
1898

Workmaster Michael Perchin, St. Petersburg. Height 5¹⁵/₁₆" (15.1 cm).
The Forbes *Magazine Collection, New York.*

Surely among the most exquisite and imaginative eggs to come out of the Fabergé workshop, the Imperial Lilies-of-the-Valley Egg is one of three done in the Art Nouveau style. The others are the Imperial Pansy Egg and the Imperial Clover Egg.

The egg, in a rich pink translucent enamel over a basket-weave *guilloché* ground, is nearly overgrown with lilies-of-the-valley formed of pearls and rose-cut diamonds on slender golden stalks. By using pearls of different sizes, the artist has accentuated the naturalism of the flowers in their entire range from tiny bud to full bloom. The leaves, also masterful in their mimicry of nature, are enameled in green. Supporting the egg are green gold leaves shaped into four cabriole legs with streaks of morning dew—rose diamonds—clinging to them. A single pearl is caught on each foot.

A diamond-studded imperial crown, surmounted by a cabochon ruby, rests atop the egg, concealing a gold-framed slit. Release the pearl-set knob at the side of the egg and the surprise springs up out of the egg through the slit. It is a trefoil of miniature portraits by Johannes Zehngraf on ivory panels framed in gold and rose diamonds. At the top, and bearing the crown, is Czar Nicholas II, and below are his two eldest children, the Grand Duchesses Olga and Tatiana. The portraits are backed with gold panels engraved with the date 5 April 1898, the day on which Nicholas presented the egg to his wife, Alexandra Feodorovna.

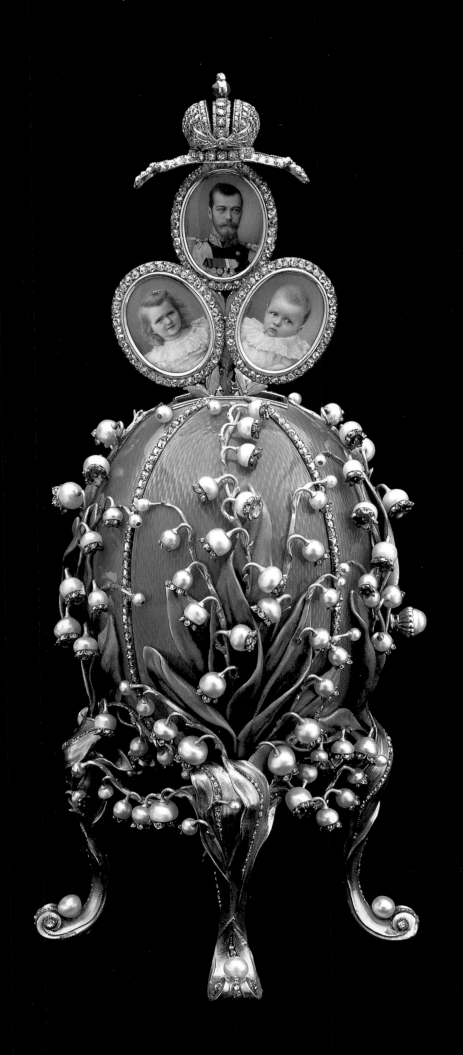

GOLD, ENAMEL,
AND JEWELED EASTER EGG
1899

Workmaster Michael Perchin, St. Petersburg. Height 3½" (8.9 cm).
The Royal Collection, London.

Though undoubtedly of imperial quality, this is not an imperial egg. It was one of several—probably seven—ordered by Alexander Ferdinandovich Kelch, the mining magnate, for presentation to his wife, Barbara, in the years from 1898 to 1904. With its delicate coloring and varied decorative techniques, it is a lovely example of the art of the goldsmith.

The upper and lower sections of the egg are each divided into six panels by bands of matte-finished gold overlaid with rows of pink enamel roses with gold stems and green leaves. The panels, decoratively framed in gold and white, are enameled in a translucent pale pink. Each panel bears an airy, underpainted design in blue, either of ribbons with leafy garlands or of bare tree branches, applied before the final coating of clear enamel. A band of rose-cut diamonds, set at intervals with rosettes of additional diamonds, circles the egg at its widest part. Each end of the egg is finished with concentric rings of diamonds, gold and green-enameled leaf motifs, and pink enamel. One end is centered with a medallion bearing the initials "BK" in script under a portrait diamond; the other end has a similar, though smaller, medallion showing the date 1899.

Like many of its imperial cousins, this Easter egg contained a surprise, which has been lost.

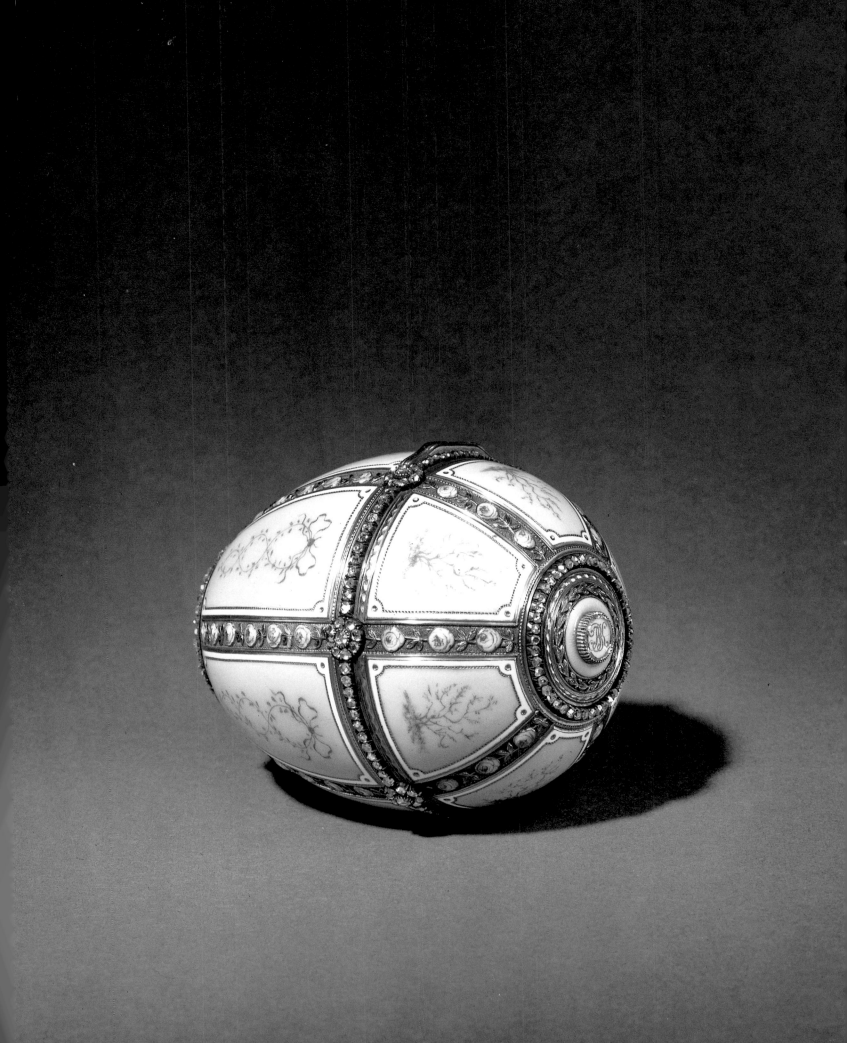

IMPERIAL MADONNA LILY EGG
1899

Workmaster Michael Perchin, St. Petersburg. Height 10½" (26.7 cm).
The Armory Museum, Moscow.

Fashioned of multi-hued gold, the Imperial Madonna Lily Egg was a gift from Czar Nicholas II to his wife Alexandra Feodorovna. It is an elaborate assemblage consisting of the egg itself, which functions as a clock, a base, and a headdress of hardstone flowers.

The egg is enameled in translucent yellow over a machine-turned ground; it is banded with rose diamonds and capped at either end by leafy motifs in green gold. The revolving chapter ring, set with diamond-studded Roman numerals, is enameled in opaque white and stands out sharply against the yellow background; a diamond arrow indicates the hour. A short stem, in matching enamel and diamonds, elevates the egg from the rectangular base, which is similarly enameled. Plumed scroll-work in different shades of gold decorates the base; the front panel bears the date in diamonds. Freestanding plumes curl upward from the top of the base, their topmost members touching the egg and becoming part of the ornamentation.

Fabergé was well known for his lifelike miniature flowers carved from various hardstones. These were often set into vases of clear rock crystal. Here, he used the technique to create a bouquet of Madonna lilies perched on top of the egg. They are naturalistically carved of white quartzite and set with rose diamonds. Rather than a vase, the green gold stems, with leaves, are held in a shallow, red gold cup rimmed with roses of white and yellow gold.

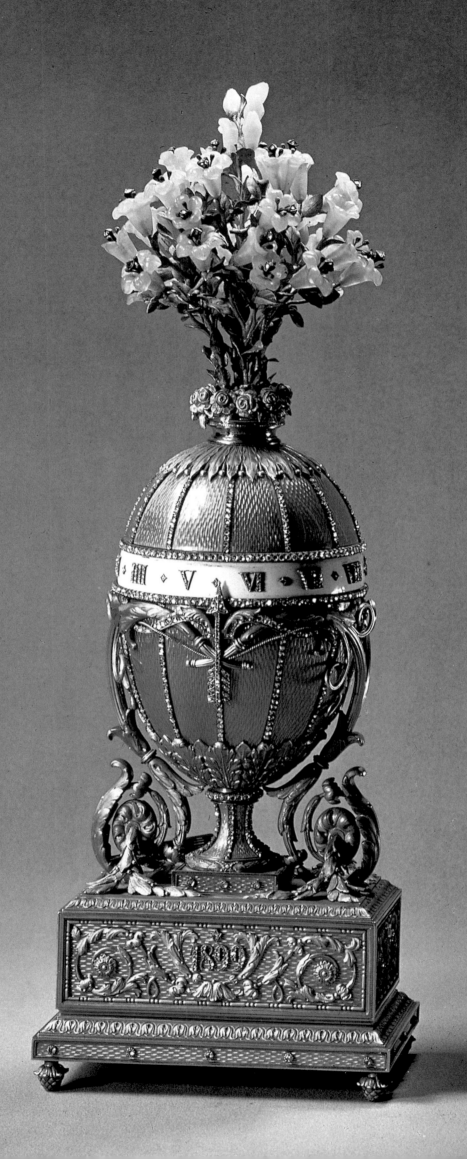

IMPERIAL PANSY EGG
1899

Workmaster Michael Perchin, St. Petersburg. Height 5¾" (14.6 cm).
Private collection, U.S.A.

The simple Imperial Pansy Egg, carved out of nephrite in a beautiful shade of green, is enhanced by flowing Art Nouveau motifs. It is the second of the three imperial Fabergé eggs to be worked in this style, the others being the Imperial Lilies-of-the-Valley Egg and the Imperial Clover Egg. The Imperial Pansy Egg was given by Czar Nicholas II to his mother, the Dowager Empress Marie Feodorovna.

The egg is nestled in a swirled base of silver gilt set with diamonds. Growing out of the base are five stems, each topped by a fully blooming pansy in lavender enamel paved with diamonds. There is a smaller, partially opened bud on each stem as well. The egg is not hinged; instead, the top may be lifted off completely to provide access to the surprise.

The surprise is a folding easel with a heart-shaped plaque of opalescent white enamel over a sunburst *guilloché* ground, framed in diamonds and topped by an imperial crown of diamonds. The easel, in chased, multicolored gold, is surmounted by a six-pointed star of diamonds within a gold laurel wreath. Just below the star is a panel bearing the date 1899, with a pearl at each side. The heart plaque is a miniature portrait gallery, comprising eleven tiny paintings, each covered by a monogrammed, red-enameled lid, of the Dowager Empress's sons and daughters, along with their spouses and children. The likeness of Nicholas is in the second row from the top, second from the left. Pressing a single button releases all the lids at the same time.

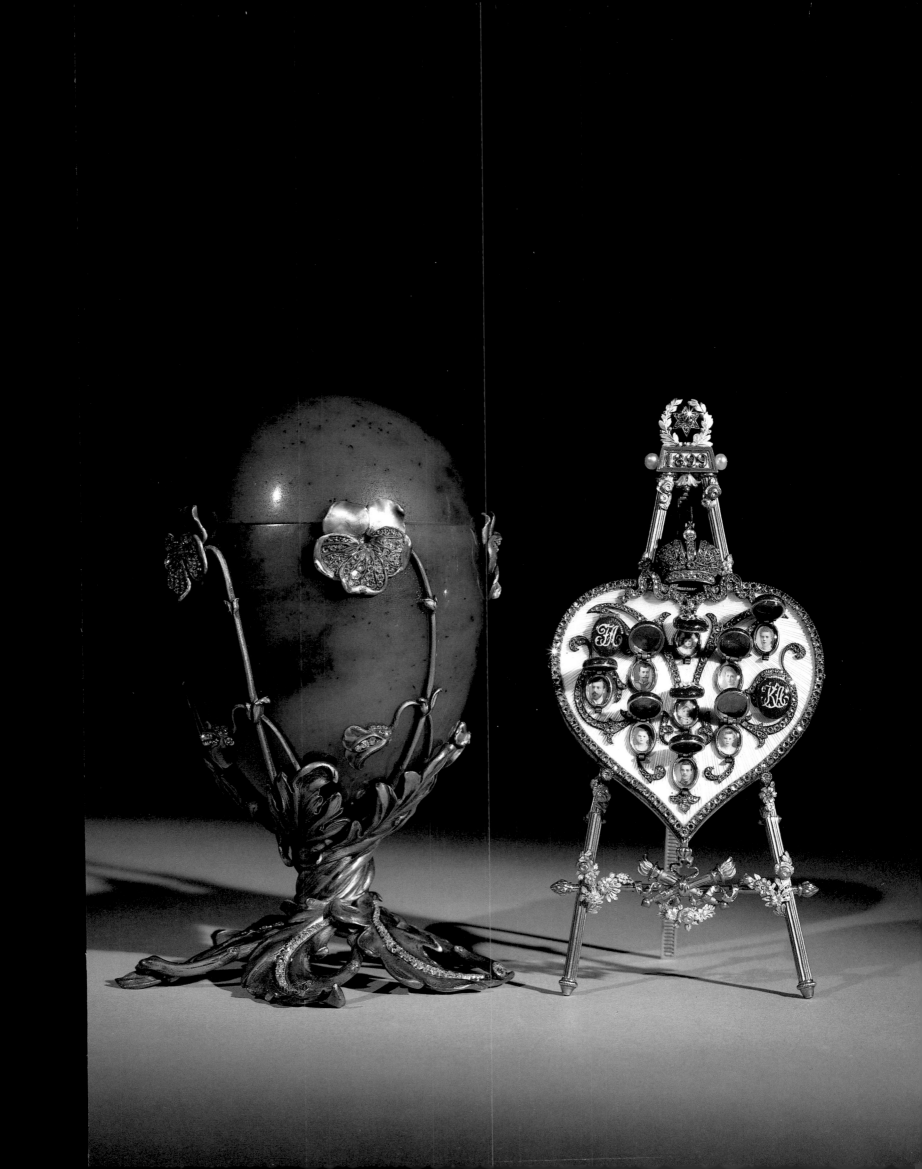

GOLD AND AGATE EASTER EGG
ca. 1900

Workmaster Michael Perchin, St. Petersburg. Height 3¼" (8.3 cm).
Courtesy of Hillwood Museum.

Little is known about this egg, except that it was not an imperial egg and that it was probably intended as a bonbonnière, or container for small candies. Its size suggests that it was not carried about, but probably kept in one place, perhaps on a table or a nightstand, ready to dispense a pastille or lemon drop to soothe a dry throat. It is carved from brown agate in two pieces and opens at the center. The gold scrollwork that forms the cage into which the egg is set is done in rococo style and is scattered with a few floral motifs. It is reminiscent of eighteenth-century English eggs made of various hardstones and set into gold cages.

The agate, with its mottled coloring, is smooth and polished to a high gloss which reflects the light and mirrors the stand in which the egg is displayed.

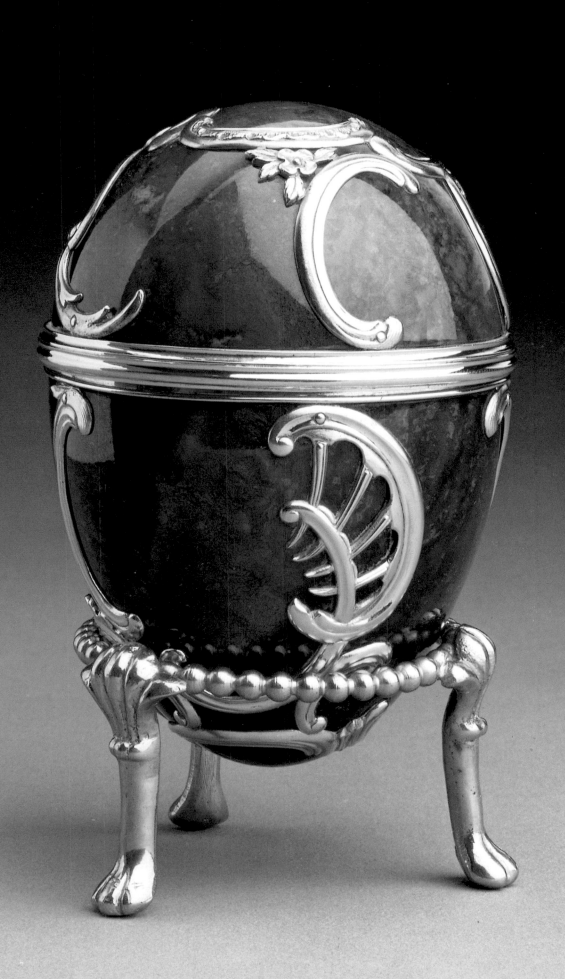

IMPERIAL TRANS-SIBERIAN RAILWAY EGG
1900

Workmaster Michael Perchin, St. Petersburg.
Height of egg 10¾" (27.3 cm); length of train 15¹¹⁄₁₆" (39.8 cm).
The Armory Museum, Moscow.

The opening of the Trans-Siberian Railway in 1900 after nine years of construction was such an important event that Czar Nicholas II had this commemorative egg made for his wife, Czarina Alexandra Feodorovna. Heralding an important new era of transcontinental travel and communication, it was, and still is, an enchanting piece, crafted with the utmost skill.

The top and bottom of the egg are enameled in a rich translucent green over a fine *guilloché* ground, and are embellished with semi-geometric designs in red and blue enamel and gold chasing. Around the center of the egg is a wide silver band, inscribed with the legend "Great Siberian Railway, 1900" as well as a map showing the 4,000-mile-long route of the rail line from Moscow in the west to Vladivostok in the east. A crowned, triple imperial eagle sits atop the egg. The egg rests on the wings and shoulders of three menacing gryphons, each brandishing a sword and a shield. These gryphons stand on a contoured, triangular base of white onyx with a filet of crimped gold.

Formed of platinum and gold, the miniature train surprise is fully articulated and runs on its wheels when wound up with a golden key. A little over a foot long and authentically detailed, it consists of a locomotive, a tender, and five coaches, the last of which represents the imperial chapel. The other coaches carry inscriptions such as "Ladies only" and "For smokers." The engine's headlamps are set with diamonds, the rear lamps with rubies.

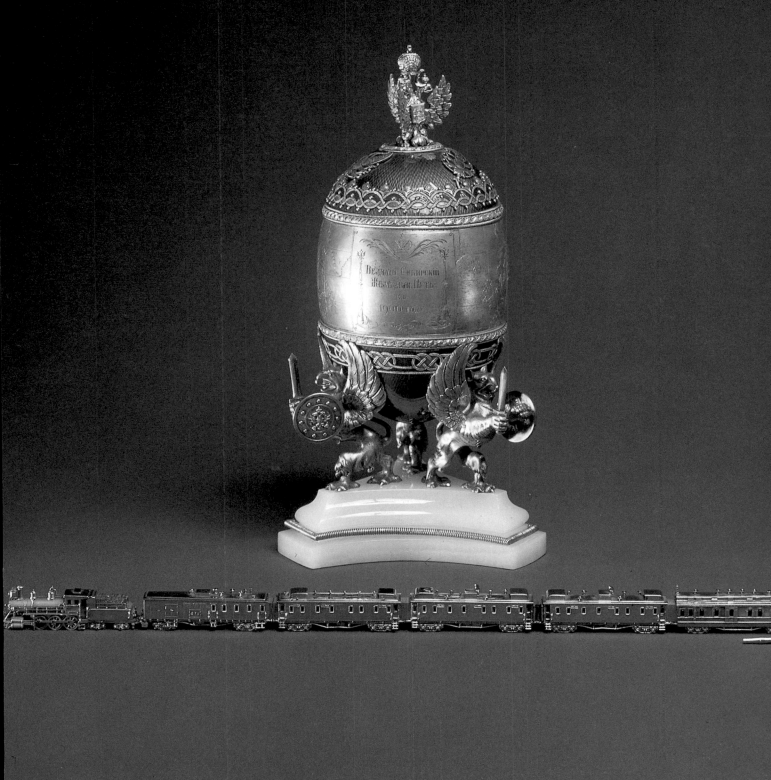

IMPERIAL CUCKOO EGG

1900

Workmaster Michael Perchin, St. Petersburg. Height 8⅛" (20.6 cm).
The Forbes *Magazine Collection, New York.*

Many elements have been combined here to create this charming egg, done in baroque style with a few Moorish touches, but unmistakably Fabergé. Enameled in deep violet-blue over a *guilloché* wave design, the egg holds a clock, framed in pearls and gold within a ring of translucent white enamel, with diamond-set Arabic numerals. The swags, lacy scallops, and garlands surrounding the clock are of vari-colored gold and are set with diamonds and pearls. The highly ornate base, enameled in translucent lilac—rather startling in combination with the blue of the egg—encased in a heavy gold mounting, is set with three large diamonds. A low pedestal and three columnar legs in translucent white enamel with gold mountings elevate the egg above the base. At the top of each column is a burning torch motif.

Despite the use of the name Cuckoo, the surprise is actually a rooster. This automaton, which operates independently of the key-wound clock, appears when a small, circular filigree grate at the top of the egg is released by pressing a knob. Sporting ruby eyes and real feathers in its tail, the bird flaps its wings, opens its beak, and sings! A miniature bellows inside the egg is responsible for creating this delightful illusion. There is more Moorish filigree work around the back of the egg; one edge is just visible at the right.

The Imperial Cuckoo Egg was presented by Czar Nicholas II to his wife Alexandra Feodorovna in 1900.

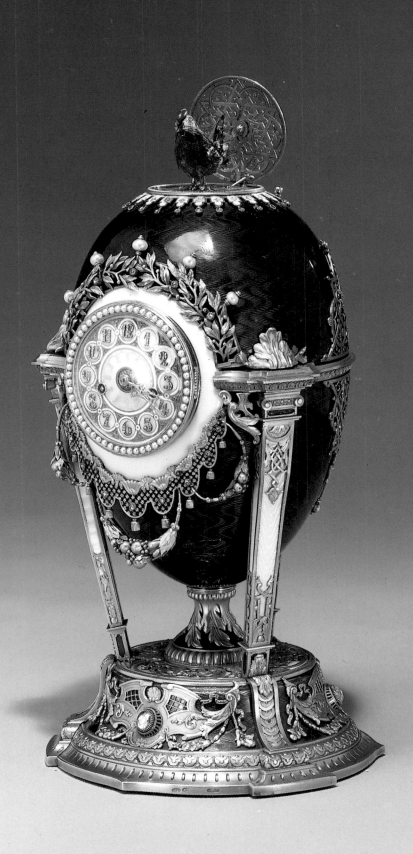

PINE CONE EGG

1900

Workmaster Michael Perchin, St. Petersburg. Height 3¾" (9.5 cm).
Mrs. Raymond Kroc, San Diego.

This may be another of the splendid Easter eggs presented to Barbara Bazanov Kelch by her husband, Alexander Ferdinandovich Kelch, between 1898 and 1904. Clearly, it has been accorded the same fine workmanship that Fabergé gave to the eggs he created for his imperial patrons, and a number of experts consider it to have been Czar Nicholas II's 1900 Easter gift to his mother.

Enameled in luminous blue over a *guilloché* ground in a radiating rib pattern, the egg is designed to simulate the staggered and overlapping scales of a pine cone. To emphasize the shape and heighten the naturalistic effect, each scale is edged with a crescent of graduated diamonds; the scales are also graduated in size, becoming larger around the widest portion of the egg and smaller at the ends. At the top of the egg is a quatrefoil of portrait diamonds mounted in gold, each covering one numeral of the date, 1900.

Happily, the surprise has been preserved along with the egg. It is a miniature gray elephant, complete with ivory tusks and an oval diamond set into its forehead. Draped over its back is a jeweled, fringed, and tasseled rug enameled in red over a *guilloché* ground. On a smaller, green rug, also jeweled and tasseled, a white-clad, turbaned mahout is perched cross-legged, a golden prod in his hand. Winding the mechanism with a gold key sets the elephant in motion. It walks in typical elephant fashion, swaying ponderously from side to side, moving its head and swishing its tail.

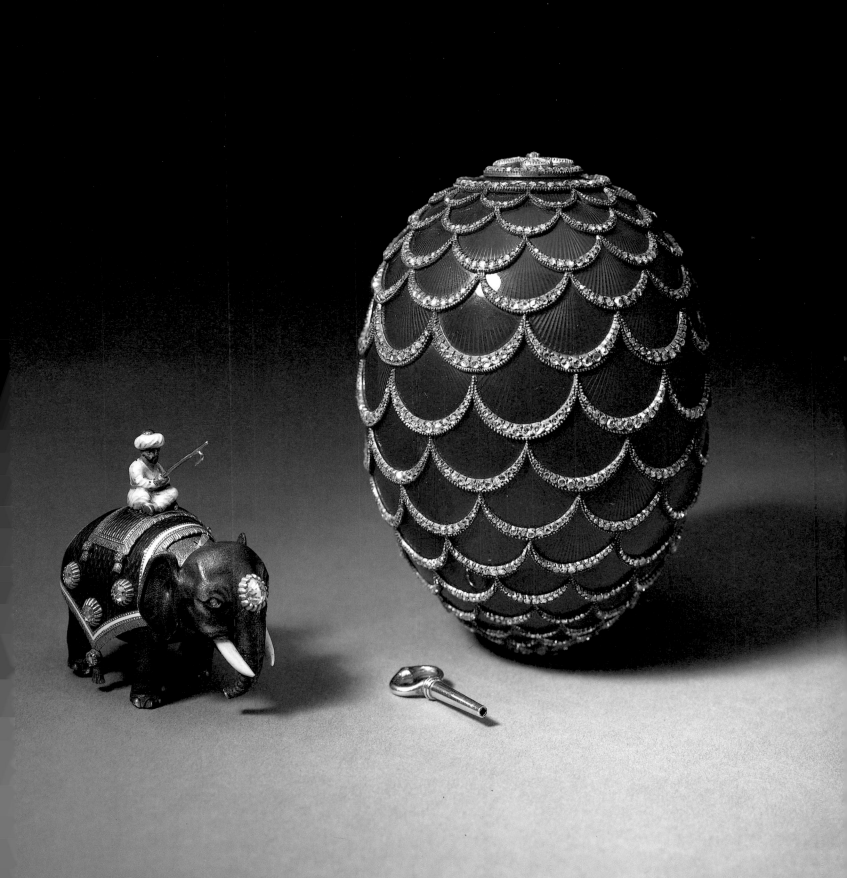

BONBONNIÈRE EGG

1900

Workmaster Henrik Wigström, St. Petersburg. Height 1⅞" (4.8 cm).
The Forbes *Magazine Collection, New York.*

For its small size, this egg has been lavished with the same craftsmanship and attention to detail characteristic of the entire Fabergé output. It may have been used as a container for pastilles, the small sugared candies popular at the time of the egg's manufacture. Its size—less than two inches long—implies that it could have been carried by its owner, like a pillbox. Coming from a container like this, the candies must have tasted very sweet.

The shell of the egg is silver gilt, machine-turned, and enameled in translucent white. Swags of green gold laurel leaves crisscrossed in red gold divide the egg into separate, rounded panels, the upper ones underpainted in sepia in a design of leafless twigs and ribbon bows, a recurring motif in Fabergé's work. In the kite-shaped spaces between the panels, a *guilloché* background of pale blue enamel is overlaid with gold trelliswork and diamond florets. Rubies held in place by red gold prongs are centered within the lower panels and also set into the swags.

The hinged upper portion, or cover, of the egg, is rimmed in gold. A band of pale blue enamel is embellished with applied green gold leaf sprays with diamonds, and just above the band, on the white-enameled portion, red gold ribbon bows have been applied.

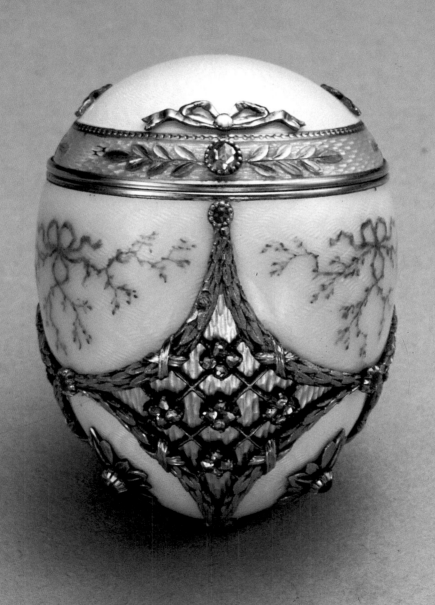

IMPERIAL CLOVER EGG
1902

Workmaster Michael Perchin, St. Petersburg. Height 3⅜" (8.6 cm).
The Armory Museum, Moscow.

The Imperial Clover Egg is the third imperial egg to be executed in the Art Nouveau style, and it is believed to have been given by Nicholas II to his wife Alexandra Feodorovna. Like the Imperial Lilies-of-the-Valley Egg and the Imperial Pansy Egg, it takes its inspiration from nature, then embellishes it. The egg is also a breathtaking example of the goldsmith's art, every bit of its surface covered over with rich ornamentation.

The clover-leaf theme has been rendered in three ways: in green *plique-à-jour* enamel with gold veining, in pavé diamonds, and, as part of the supporting stand, in chased gold. The exuberant tangle of clover has been interwoven with a ribbon of gold set with faceted rubies. This ribbon can be seen snaking in and out among the foliage in no discernible pattern, leaving a glowing trail of color in its wake. The randomness of the design conveys a cheerful sense of freedom.

The egg is propped near its bottom in an almost-too-delicate, three-legged gold bracket of clover leaves and curving stems, with inward-facing foliate feet. As was true of most imperial eggs, this egg could be opened to reveal a surprise (note that the edges of the top and bottom halves of the egg are almost hidden by the cleverly placed clover leaves). Regrettably, the surprise is now lost. One cannot help wondering what it might have been.

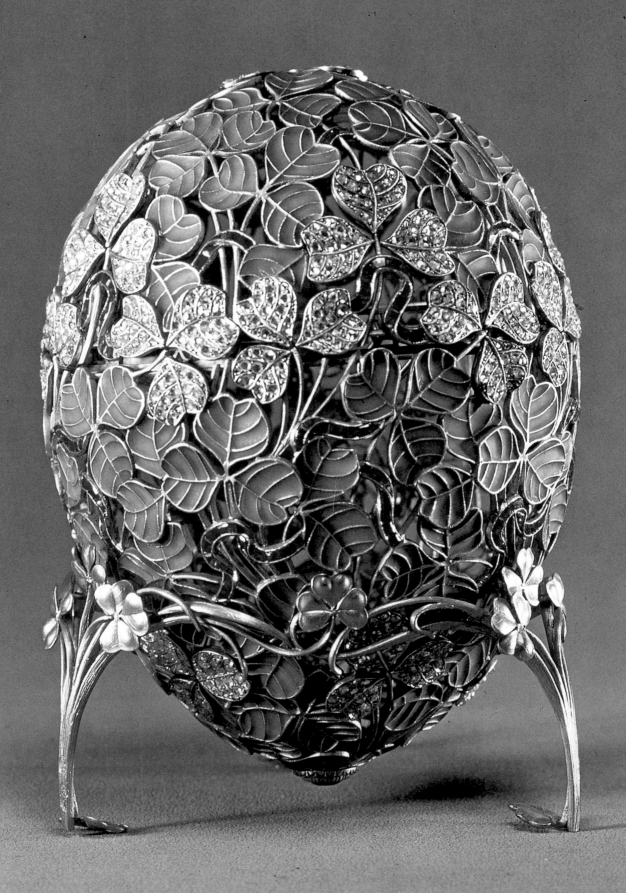

IMPERIAL GATCHINA PALACE EGG

ca. 1902

Workmaster Michael Perchin, St. Petersburg. Height 5" (12.7 cm).
Walters Art Gallery, Baltimore, Maryland.

The Imperial Gatchina Palace Egg was a gift from Czar Nicholas II to his mother, the Dowager Empress Marie Feodorovna. It must have held a special significance for her, since it represented two of her personal interests: the arts and sciences and her accustomed residence.

Rows of seed pearls divide the surface of the egg into panels and also separate the top and bottom sections by running around the circumference at the widest point. Enameled in opalescent white over a *guilloché* ground of moiré design, the egg is underpainted in a delicate, airy design of green and gold leaves, pink roses, and red ribbons tied into a variety of bows. Among the several objects depicted, a tambourine, horns, an artist's palette, and flaming torches can be interpreted as symbols of the arts and science.

Marie Feodorovna, born Princess Dagmar of Denmark (she took her Russian name before marrying Alexander), was well-liked by the Russian people. She loved court life, and was known to be both charming and witty. She enjoyed dancing and was in her element at a party or a ball. The design of the Gatchina Palace Egg, with its festive motifs, easily invokes the spirit of a royal gala.

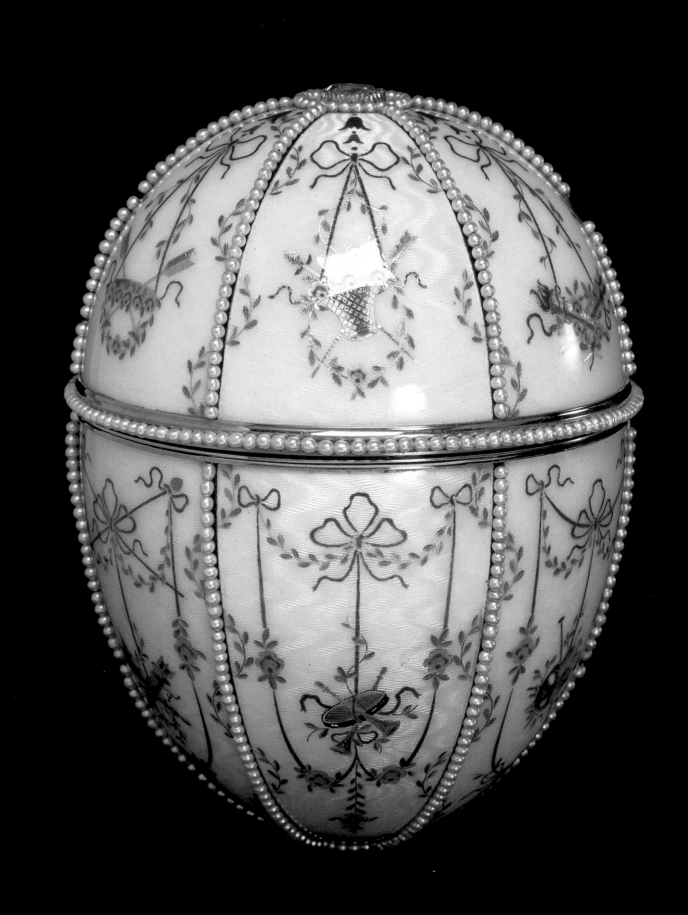

IMPERIAL GATCHINA PALACE EGG

(OPENED)

The Gatchina Palace, located twenty-five miles southwest of St. Petersburg, was the customary home of Marie Feodorovna and her family during the reign of her husband Czar Alexander III. Although Marie would have been happy to live in town all year round, she deferred to her husband's preference for this home away from the city. So the future Czar Nicholas, his two brothers, and his two sisters were brought up largely at Gatchina. Despite its appearance of luxury and its 900 rooms, however, Alexander insisted on observing a spartan regime for his children, including army cots for sleeping, cold baths, and simple food. Evidently he did not want them to grow up spoiled.

Under a velvet-lined cover, the surprise awaits. It is a faithful miniature replica of the Gatchina Palace. Crafted of four-color gold, it is meticulously detailed, with statuary, lampposts, and a flag flying from one of the turrets. Even the landscaping has been accurately rendered, from the graveled courtyard and walkways to grassy plots with bushes and trees. One can almost hear the clip-clop of the carriage horses' hooves.

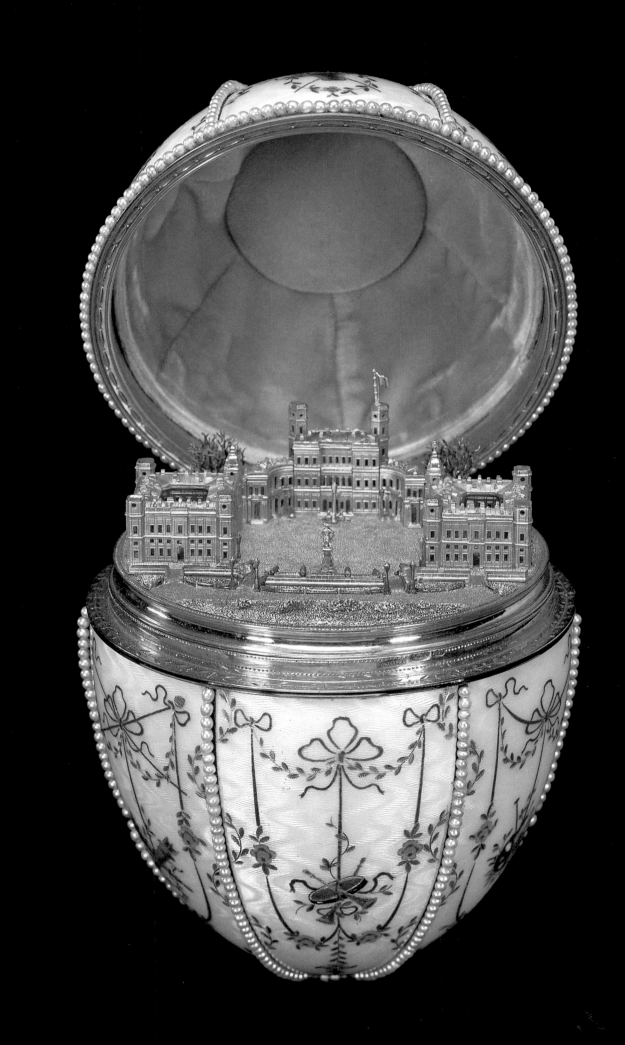

IMPERIAL PETER THE GREAT EGG
1903

Workmaster Michael Perchin, St. Petersburg. Height 4¼" (10.8 cm).
Virginia Museum of Fine Arts, Richmond.
Bequest from the Estate of Lillian Thomas Pratt, 1947.

This superb egg in rococo style is executed in vari-colored gold and platinum, and is embellished with flourishes and swirls of rose-cut diamonds and touches of white enamel. Chased all over in a design of scrolls, leaves, and marsh grasses, it is scattered about with white and gold flowers and ruby-studded cattails. Miniature paintings set into the surface portray Czars Nicholas II and Peter I (popularly known as Peter the Great), the Wooden Hut of Peter the Great, and the Winter Palace in St. Petersburg.

The egg was a gift to Czarina Alexandra Feodorovna from her husband, Nicholas II. The date of presentation, 1903, is displayed in diamonds on the upper portion of the egg, and it commemorates the bicentennial of the founding of St. Petersburg by Peter the Great, who ruled Russia from 1682 until his death in 1725.

Born in 1672, Peter is regarded as the founder of modern Russia. Although he was at times cruel and tyrannical, he brought about many beneficial changes, such as the introduction of military technology, civil-service reform, and increased foreign trade. The city that he founded in 1703 along European lines, now known as Leningrad and no longer the capital, has always been regarded as the cultural center of Russia and is still so regarded in today's Soviet Union.

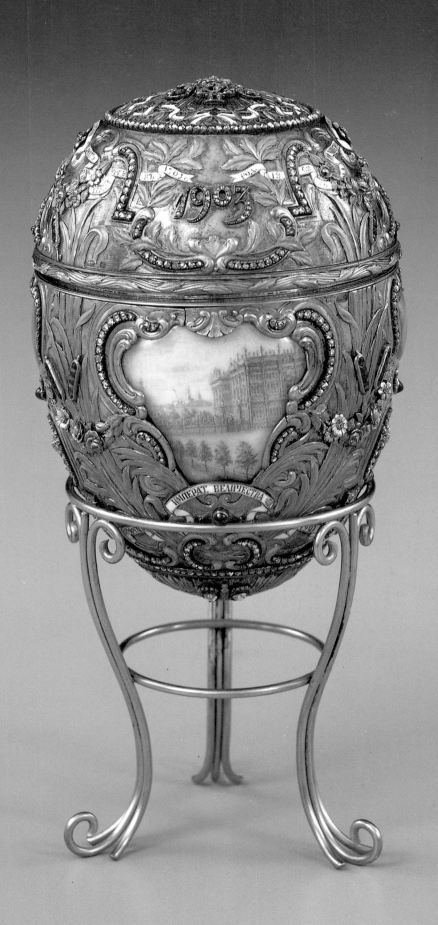

IMPERIAL PETER THE GREAT EGG

(OPENED)

The interior of the Imperial Peter the Great Egg is as magnificent as the exterior. The inside of the cover is machine-turned and enameled in translucent sunny yellow; the lip, or inner edge, of the opening is chased in gold. When the cover is raised, an elevating mechanism lifts the platform holding the surprise into position. This miniature statue of Peter the Great is an exact replica of the one erected along the River Neva in St. Petersburg in 1792. The original, in bronze, was commissioned by Catherine the Great (Empress of Russia from 1762 to 1796) to the French sculptor Falconet. The replica, in gold, was created by Malychev. Its base is an irregular, though highly polished, slab of sapphire, on which the Russian names of Peter and Catherine, as well as the date 1792, have been carved and highlighted in gold. (Although the statue was meant to honor Peter the Great, Catherine, a legendary ruler in her own right, made sure that she received equal billing.)

Surrounding the statue is a finely wrought, low circular fence of gold, outside of which is a second fence of gold posts and chains. The entire platform—statue, base, and fences—can be removed from the egg.

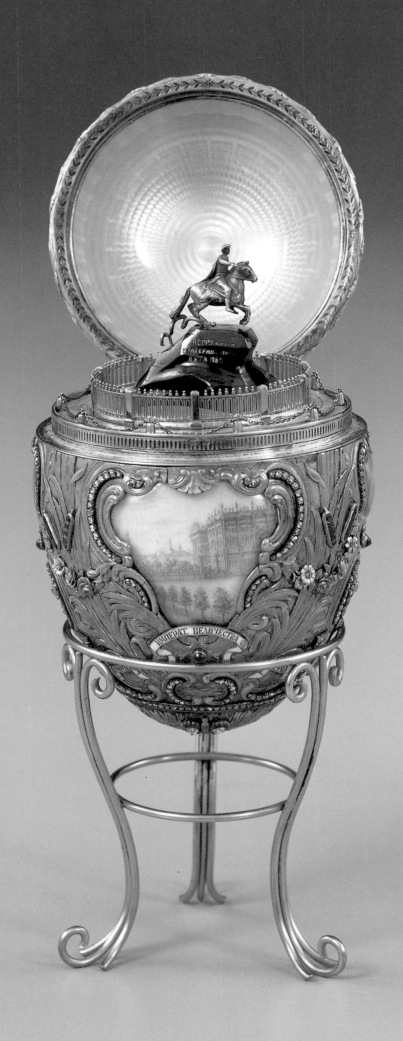

IMPERIAL USPENSKY CATHEDRAL EGG
1904

Height 14½" (36.8 cm).
The Armory Museum, Moscow.

This fantasy, a gift from Czar Nicholas II to the Czarina Alexandra Feodorovna, is one of the largest imperial eggs created by Fabergé. It represents, in fairy-tale style, the onion dome of the Uspensky Cathedral within Moscow's Kremlin, significant as the traditional site of the Czars' coronations. For Nicholas and Alexandra, this event took place on May 26, 1896.

The architectural elements, which stand upon an onyx base, are constructed of multicolored gold, textured to suggest the bricks and stones of the actual walls and towers of the compound. Arches, both round and pointed, denote windows and gateways, complete with "wrought iron" gates in gold. The various domes and spires atop the towers are enameled in brilliant green over a *guilloché* ground and are surmounted by different symbols, such as a flag, a cross, and an imperial eagle. Two of the towers have clock faces, and in the center of the lower wall a niche contains a colorful icon.

Dominating the ensemble is the cupola itself, which serves as the top half of the egg. The dome, executed in green gold that has been engraved in a squared-off pattern, rises to a peak topped by a large Russian cross. The bottom half of the egg—the cathedral—is enameled in white. Through the arched windows, the altar and frescoes may be viewed, and, to heighten the religious atmosphere, a hymn can be played by winding the mechanism with its gold key.

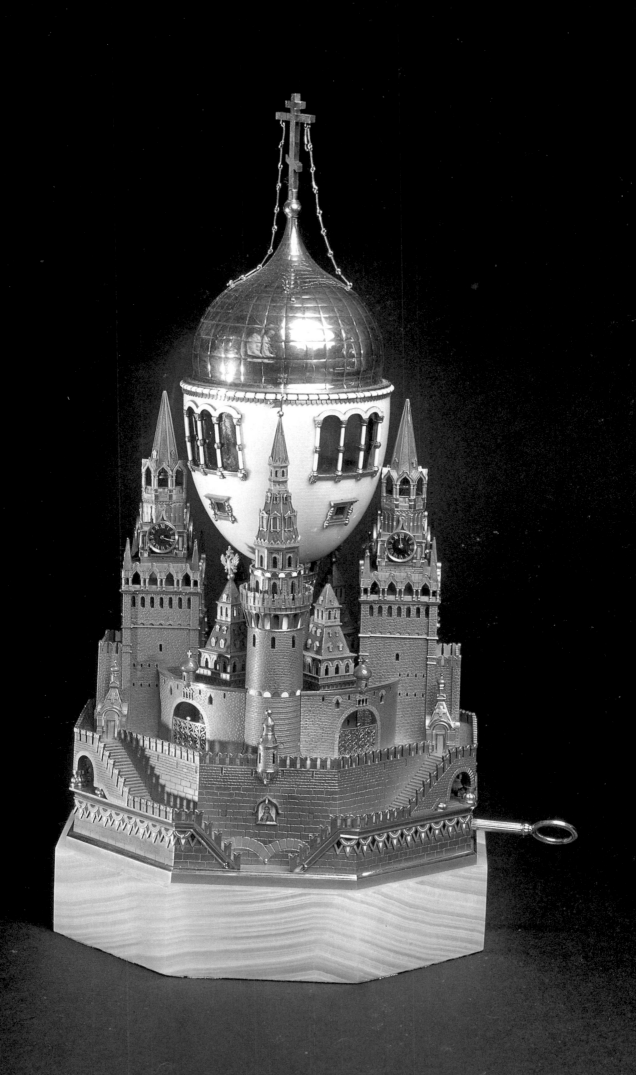

IMPERIAL COLONNADE EGG
PROBABLY 1905

Workmaster Henrik Wigström, St. Petersburg. Height 11 ¼" (28.6 cm).
The Royal Collection, London. Collection of H.M. Queen Mary.

Given by Nicholas to Alexandra Feodorovna, the Imperial Colonnade Egg is believed to have marked the birth of the couple's only son, the Czarevich Alexei, in 1904. The Czar and his wife had four daughters, born in 1895, 1897, 1899, and 1901, but tradition and perhaps personal preference dictated a strong desire for a son and heir. And at last, much to the joy of the parents and of the Russian people, this wish was fulfilled.

The Imperial Colonnade Egg is incorporated into a romantic structure modeled on a Greek Temple of Love, whose base, columns, and roof are made of pale green bowenite with vari-colored gold mountings. Six faceted columns with neo-Ionic capitals are wound in a spiraling fashion with gold flower garlands, and similar, larger garlands festoon the base. Within the colonnaded temple, a pair of platinum doves nuzzle each other from a pink-enameled pedestal that echoes the coloring of the base. The pink-enameled egg set into the roof of the temple is a working clock, with a revolving chapter ring set with rose-diamond Arabic numerals. A diamond-studded arrowhead points to the hour.

The silver-gilt Cupid, armed with the tools of his trade and seated on top of the egg, is thought to represent the Czarevich, while the four cherubs positioned around the base in various natural attitudes, also in silver gilt, represent his four older sisters.

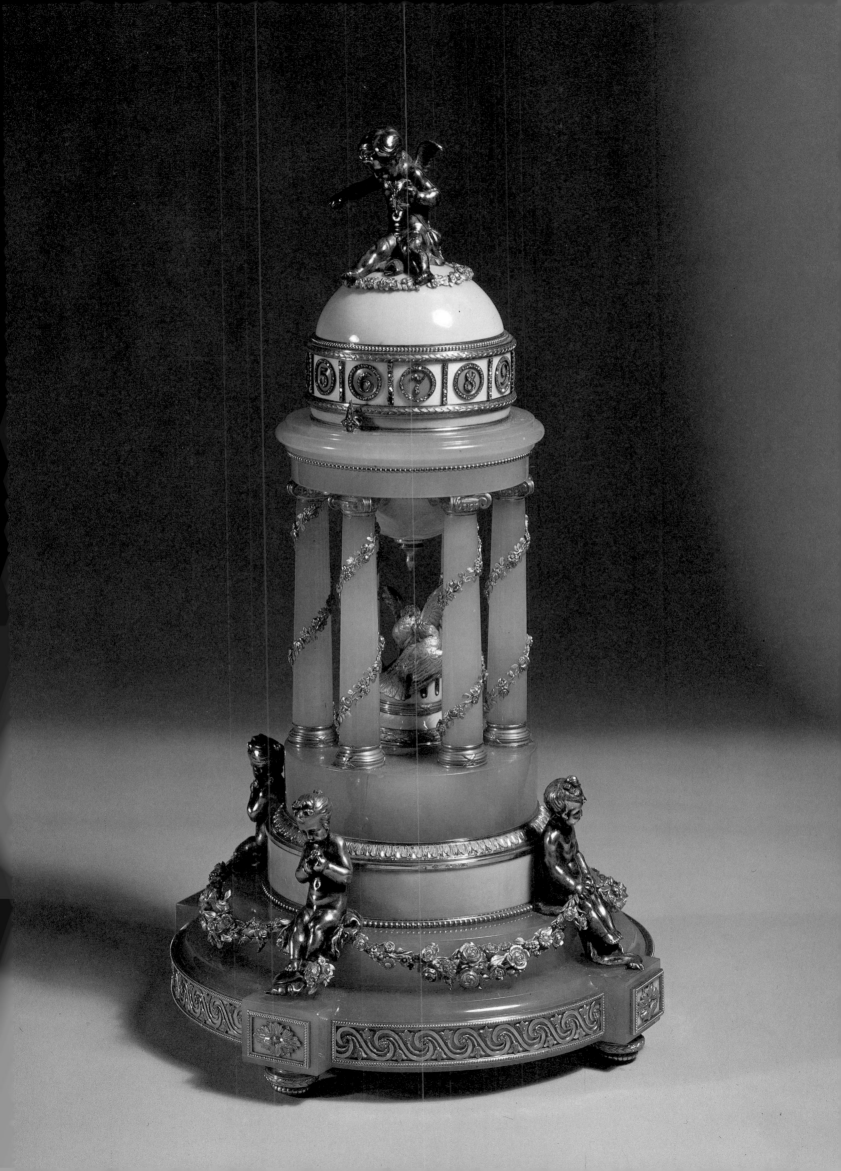

IMPERIAL ROSE TRELLIS EGG
1907

Workmaster Henrik Wigström, St. Petersburg. Height 3 1/16" (7.7 cm
Walters Art Gallery, Baltimore, Maryland.

This small masterpiece may have been a gift from Czar Nicholas II to his wife, Alexandra Feodorovna. It is one of the prettiest, most feminine eggs in the entire range of imperial eggs. The background of the Imperial Rose Trellis Egg has a machine-turned, all-over textured pattern, enameled in transparent light green enamel. The trellis, set with rose-cut diamonds and contoured to the curves of the egg, has been applied over the entire surface, culminating in a large diamond at the top. The spaces formed by the trellis are filled with roses enameled in shades of pink to resemble their counterparts in nature; as the spaces become smaller, so do the blossoms. (In technique and coloring, these enameled roses are similar to the ones found in the 1898 Kelch Hen Egg.) The naturalistic, vinelike branches from which the roses spring are gold, with leaves of dark green enamel.

A work of great delicacy, the egg opens to reveal an interior lined in satin. Although the surprise is lost, the impression left in the lining indicates that the surprise was probably an oval locket.

There is no doubt that some of Fabergé's most attractive works were greatly influenced by his view of nature, especially flowers. His rendering of flowers, whether of gold, enamel, gemstone, or hardstone, is truly inspired.

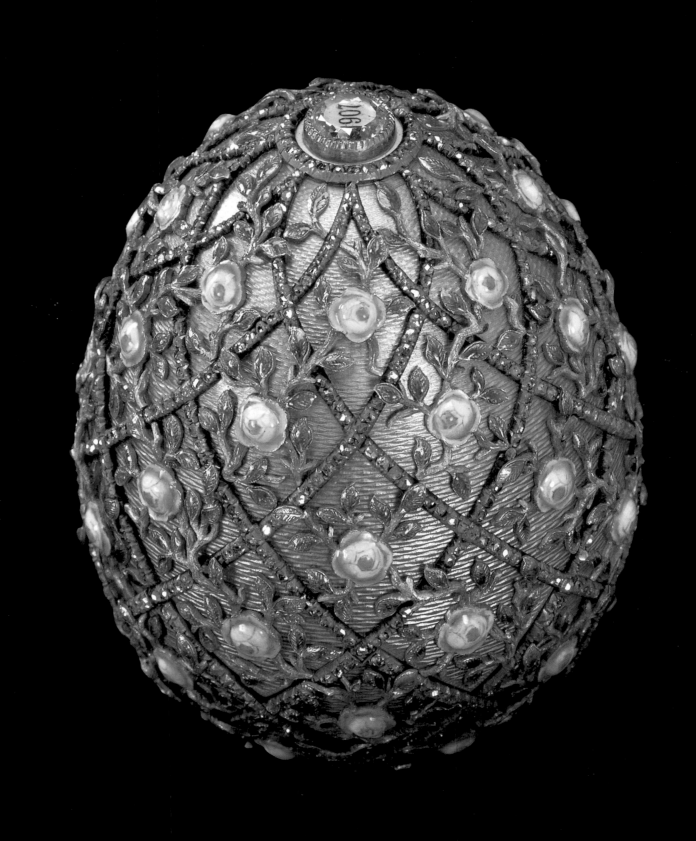

IMPERIAL *STANDART* EGG
PROBABLY 1909

Workmaster Henrik Wigström, St. Petersburg. Height 6⅛" (15.6 cm).
The Armory Museum, Moscow.

Another of Fabergé's rock crystal creations, the Imperial *Standart* Egg is so named because it showcases a gold replica of the imperial yacht *Standart*. It was presented to Czarina Alexandra Feodorovna by Czar Nicholas II, probably in 1909. The *Standart*, a 4,500-ton, steam-driven vessel built in Denmark, was the Czar's favorite yacht. He used it for pleasure cruises with his family, especially a yearly outing to the islands along the coast of Finland, and for diplomatic and political missions as well.

The transparent egg, resting on its side, is supported on a pedestal formed of two lapis-lazuli dolphins, their tails intertwined. At either end, two imperial eagles of lapis, one of them crowned, serve as handles. Their wings are spread, and their bodies virtually drip with jewels (including a large, teardrop pearl dangling from each one). The lower portion of the egg is bisected and edged with bands of multicolored enameled gold and is set with diamonds. Inside, authentically detailed down to its rigging, the miniature yacht "sails" on its own patch of the sea, a block of aquamarine.

Rock crystal is also used for the egg's circular, tiered base, which is mounted in gold and set with diamonds. It is embellished by carving, white enamel ribbed in gold, and green swags. The two blue enamel bands encircling the base complement the lapis dolphins and eagles.

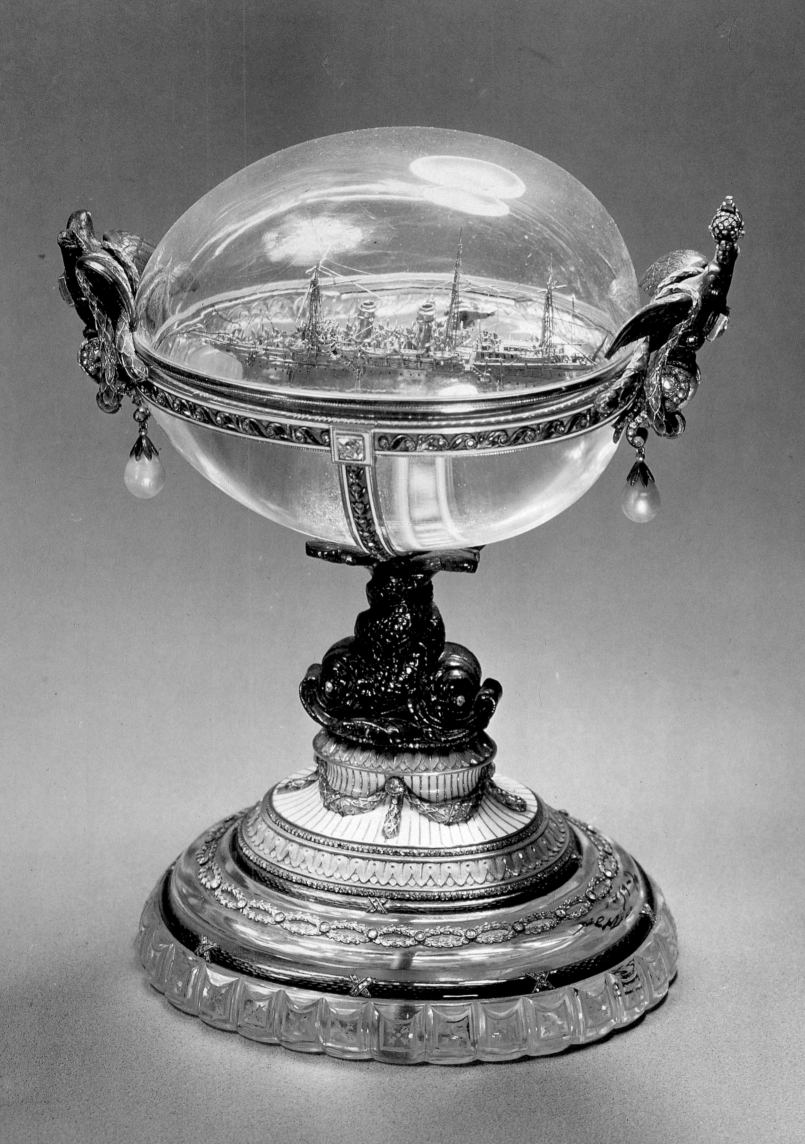

IMPERIAL ALEXANDER III EQUESTRIAN EGG
1910

Height 6⅛" (15.6 cm).
The Armory Museum, Moscow.

In 1910, a bronze statue of Czar Alexander III, created by the sculptor Paul Troubetskoy, was unveiled in St. Petersburg. Unlike the statue of Peter the Great, it is a rather sedate work, the stocky horse standing humbly with its head down, the Czar mounted squarely in the saddle. To commemorate the unveiling, Czar Nicholas II commissioned the Imperial Alexander III Equestrian Egg and presented it to his mother, the widow of Alexander, the Dowager Empress Marie Feodorovna.

The polished rock crystal egg is mounted in platinum so as to create a window effect on either side, with delicate etching around the edges. Displayed inside is a gold replica of the equestrian statue of Czar Alexander, resting on a substantial block of lapis-lazuli accented by a band of diamonds. The stone is signed in Cyrillic and is dated 1910. Closely resembling crocheted lace, the shallow-domed cap worn by the egg is a fine trelliswork of platinum intersected by rose diamonds, with diamond-studded scallops and "fringe" around the lower edge and a large diamond button at the top. The trellis design is repeated at the bottom of the egg, where it is etched into the crystal.

Also made of rock crystal, the quatrefoil base is elaborately carved. Four diamond-set platinum volutes with winged cherub heads rise from the corners of the base to serve as supports for the egg.

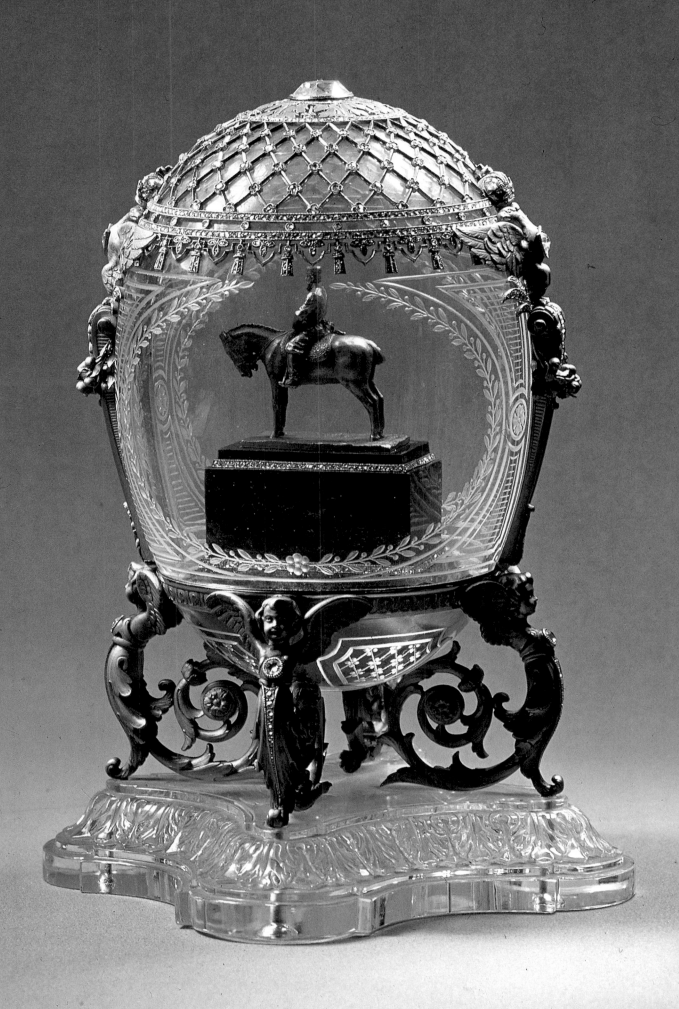

IMPERIAL FIFTEENTH-ANNIVERSARY EGG

1911

Height 5⅛" (13 cm).
The Forbes Magazine Collection, New York.

Shown here in its actual size, the Imperial Fifteenth-Anniversary Egg is a personal record of important events and places in the lives of the imperial family. Fifteenth anniversary refers to the coronation of Czar Nicholas II in 1896, and in honor of this anniversary he presented this egg to his wife, Czarina Alexandra Feodorovna.

The shell of the egg is gold and is enameled in pearly white. It is divided into eighteen panels by bands of laurel leaves outlined in gold and enameled in rich green, with bindings of rose diamonds at each intersection. The panels, narrowly framed in white enamel and gold, contain miniatures painted on ivory by Zuiev. These consist of seven oval portraits, rimmed with diamonds, of the imperial family; nine views of places and events associated with the life of Czar Nicholas II; and two round plaques, one bearing the date 1894 (the year of the Czar's marriage), the other 1911. Included among the depicted events are the procession to the Uspensky Cathedral and the moment of coronation.

Under a large table diamond at the top of the egg, the Czarina's monogram appears in black enamel. This diamond is circled by small rose diamonds mounted in chased gold. A large rose diamond is set in similar fashion into the bottom of the egg.

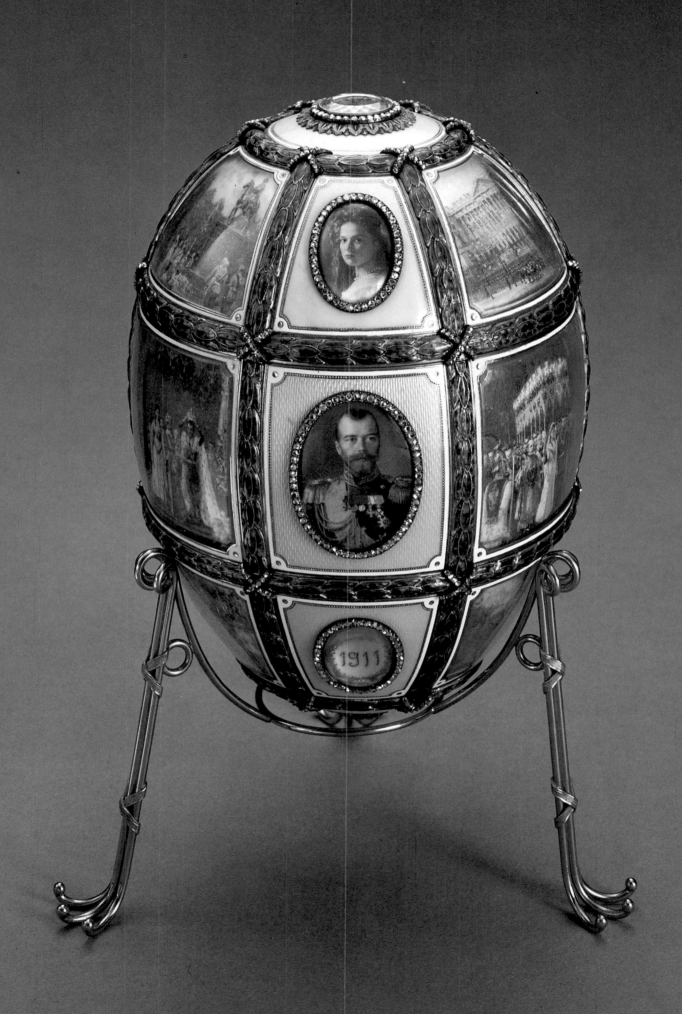

IMPERIAL FIFTEENTH-ANNIVERSARY EGG
(DETAIL)

By 1911, Nicholas II had been Czar for more than fifteen years, having succeeded to the throne in November of 1894 when his father, Czar Alexander III, died unexpectedly at the age of forty-nine. The fifteenth anniversary is that of his coronation, which did not take place until the spring of 1896. Because Alexander expected to live to old age, he put off educating his son for his eventual duties as Czar; therefore Nicholas was not very well prepared at the time of his succession. Though he was sincere and well-meaning, he had his troubles with his ministers, the Duma (parliament), and the growing influence of the self-styled holy man Rasputin on his wife, who was obsessed by the Czarevich Alexei's illness (the nature of which, incidentally, was not made public). Still, in 1911, he was secure in the knowledge that he was beloved by the Russian people.

Pictured in the detail of the Imperial Fifteenth-Anniversary Egg shown here, in the center, is Czar Nicholas II, wearing the uniform of the Guards and the ribbon of the Order of St. Andrew. The portrait above Nicholas is that of Grand Duchess Tatiana, his second daughter. The other portraits are of Czarina Alexandra Feodorovna, the Grand Duchesses Olga, Marie, and Anastasia, and the Czarevich Alexei. The date-bearing plaques below the Czar's and Czarina's portraits are signed "Fabergé."

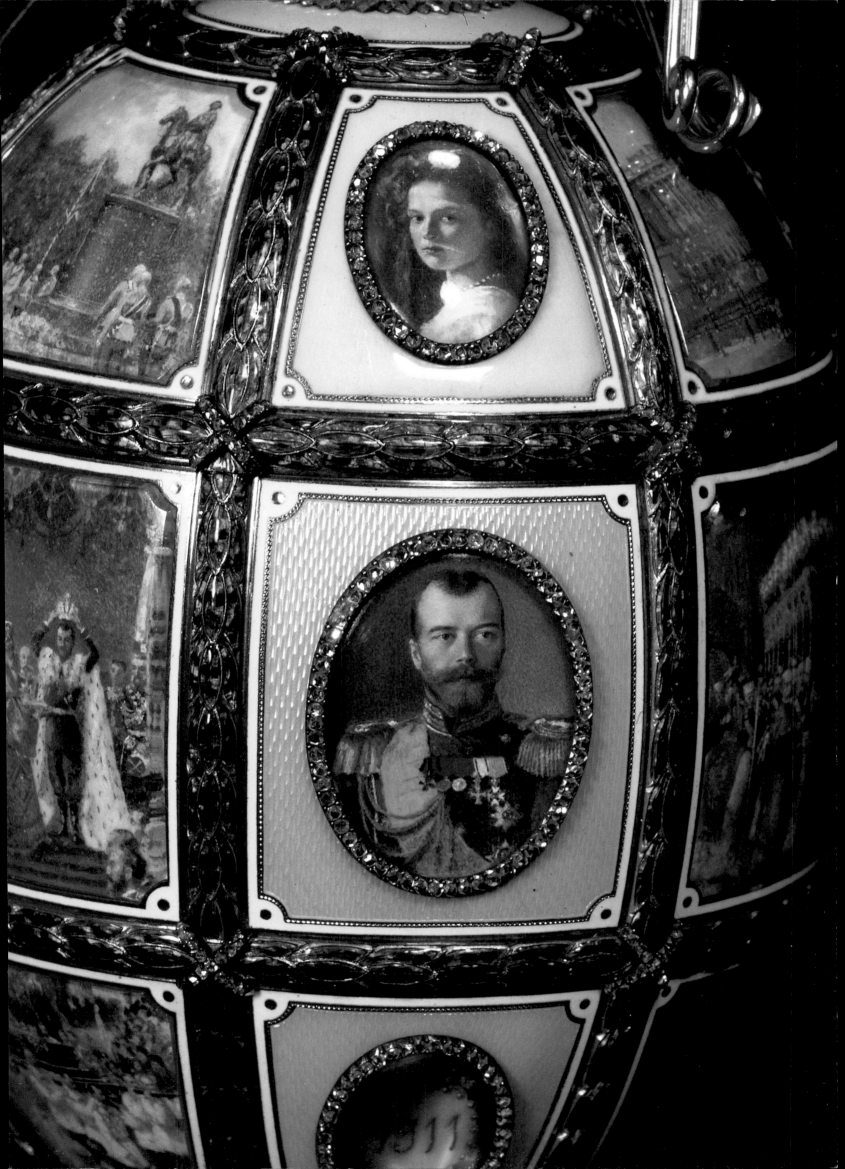

IMPERIAL ORANGE TREE EGG

1911

Height 10¾" (27.3 cm).
The Forbes Magazine Collection, New York.

This exquisite creation, a topiary tree in the shape of an egg, was given to the Dowager Empress Marie Feodorovna by her son Nicholas. It is one of the most beautifully detailed and executed of all the imperial Fabergé eggs. The tree, on a trunk of gold chased to simulate bark, is made up of individual leaves carved from nephrite and attached to gold branches. The oranges, scattered among the foliage, are round and oval faceted stones—pink diamonds, amethysts, and citrines. The tiny blossoms are white enamel with diamond centers.

The tree grows out of a square planter (with feet) of white agate with gold trellises applied to each of its sides. Swags of gold with green enamel are fastened to the planter with cabochon rubies. Similar rubies in gold mountings are applied to the feet, and pearl finials accent the upper corners of the planter. The simple base on which the planter rests is nephrite. At each corner, a nephrite post trimmed with gold and topped with a pearl anchors a swag of green-enameled gold leaves and pearls.

And the surprise? When the appropriate jewel-orange is touched, a concealed lid opens and a little bird pops up. Sporting real feathers, the bird—a nightingale, perhaps—flaps its wings, moves its beak, and sings.

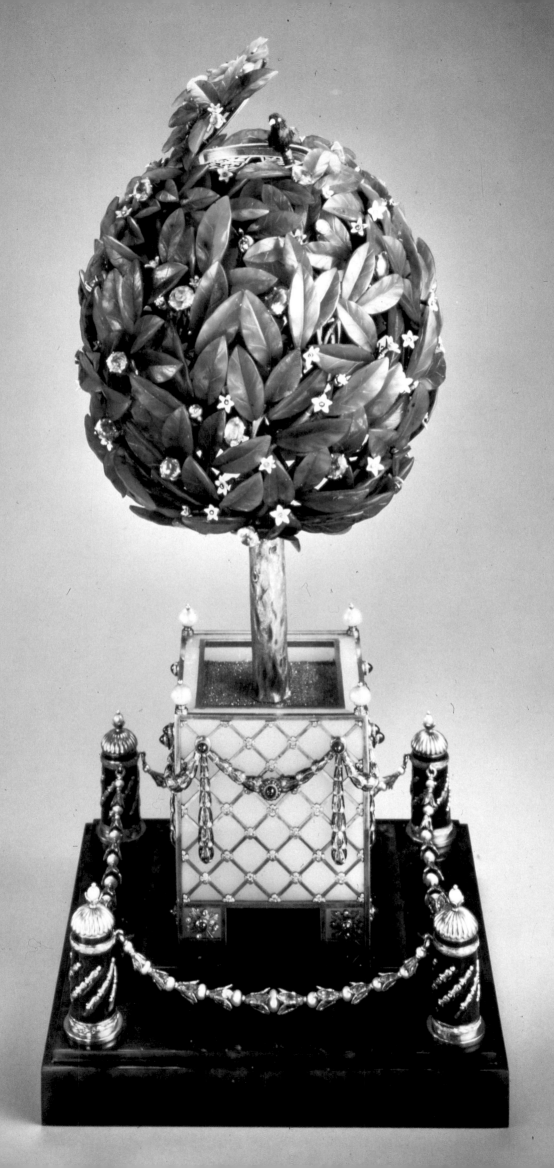

IMPERIAL CZAREVICH EGG

1912

Workmaster Henrik Wigström, St. Petersburg. Height 5" (12.7 cm).
Virginia Museum of Fine Arts, Richmond.
Bequest from the Estate of Lillian Thomas Pratt, 1947.

Carved from lapis-lazuli shimmering with flecks of gold, the Imperial Czarevich Egg was presented to Alexandra Feodorovna by her husband, Czar Nicholas II. The Czarina's initials, along with an imperial crown and the date of presentation, 1912, may be seen under a table diamond at the top of the egg. Chased gold cagework in the style of Louis XV covers the entire egg, featuring various motifs such as scrolls, shells, seraphs, flowers in baskets, and a crowned, double-headed imperial eagle.

Inside the egg is the removable surprise, another double-headed imperial eagle, totally encrusted in diamonds, and supported on a base of lapis. The eagle clutches an orb and scepter in its talons. In the center of the eagle is a miniature oval likeness of the young Czarevich Alexei, clad in his usual sailor suit. Like the eagle, the portrait is reversible; the reverse shows the back of the Czarevich's head and shoulders.

At the time of the egg's presentation, Alexei was eight years old. Despite his hemophilia, an illness that often caused him and his parents much anguish, he was treated as much as possible as a normal boy. He had a sunny disposition and was cheerful and loving with his family, and when he appeared in public he was always received with cheers.

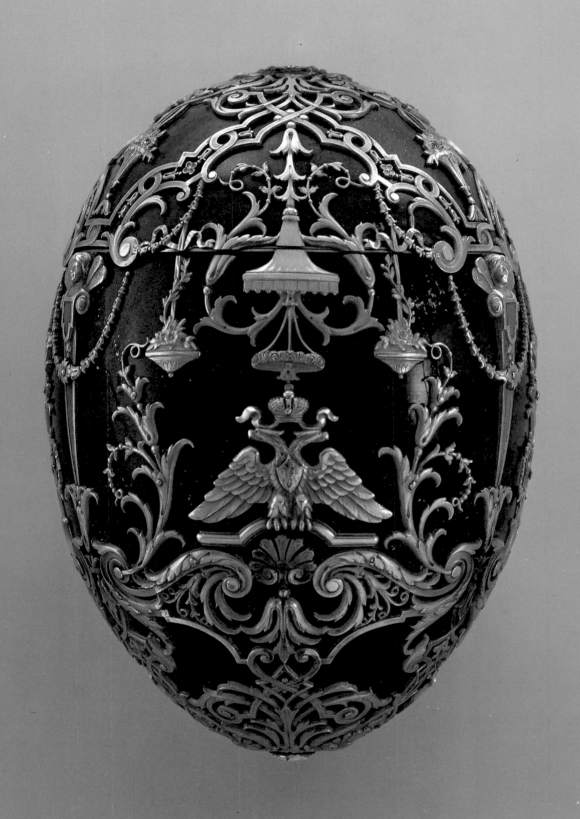

IMPERIAL NAPOLEONIC EGG
1912

Workmaster Henrik Wigström, St. Petersburg. Height 4⅝" (11.7 cm).
Matilda Geddings Gray Foundation,
on loan to the New Orleans Museum of Art.

As a memento of the Russian victory over Napoleon at Borodino, Czar Nicholas II presented this one-hundredth-anniversary egg to his mother, the Dowager Empress Marie Feodorovna. From the profusion of military motifs that make up most of the decor, there can be no doubt that this egg is a tribute to victorious battle.

The gold shell is enameled in translucent green over a *guilloché* ground of sunbursts. Vertical and horizontal bands of diamonds and chased gold leaves touched with red enamel divide the egg into six panels around the central circumference. Each panel bears a golden collage of martial artifacts, for example, a helmet, a quiver of arrows, a battle-axe, and a bugle. One panel has an emblem based on the imperial double-headed eagle. Above and below the panels are wide bands with rosette motifs, some set with diamonds, and flourishes of gold. At the ends of the egg, table diamonds mounted in gold overlie the Empress's initials at the top, and the date at the bottom.

The surprise contained inside the egg is a folding screen comprising six panels in the shape of elongated octagons. Each panel is bordered in diamonds and framed by green-enameled gold laurel leaves; the panels are separated by and hinged to ribbed gold uprights set with diamonds and topped with halberd-like blades. On the front of the panels, miniature paintings by Vasiliy Zuiev depict the regiments of which the Dowager Empress was an honorary colonel. The reverse of each panel, in white enamel over a *guilloché* ground, bears a green and gold medallion with the Empress's crowned monogram in diamonds.

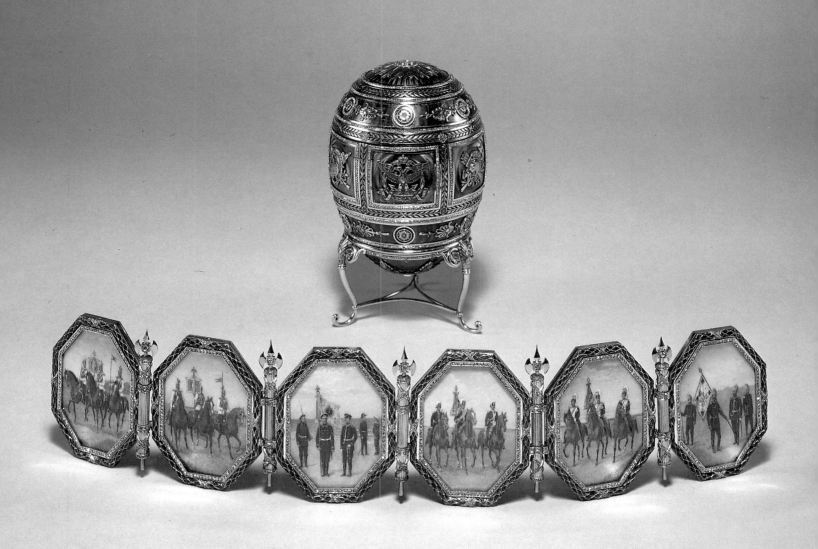

IMPERIAL ROMANOV TERCENTENARY EGG
1913

Workmaster Henrik Wigström, St. Petersburg. Height 7⁵/₁₆″ (18.6 cm).
The Armory Museum, Moscow.

This lavishly decorated egg was presented by Czar Nicholas II to his wife Alexandra Feodorovna to coincide with the 300th anniversary of Romanov rule. As celebrated in St. Petersburg, the occasion was marked by religious services, parades, and diplomatic ceremonies.

The egg's opalescent white enamel finish over a fine *guilloché* ground is almost completely hidden by the cagework of chased gold that covers its surface. The predominant and repeated motif is the imperial double-headed eagle, sword and scepter grasped in its claws, along with crowns of various styles and swirls that have been incorporated into the sumptuous pattern. Set into the egg are eighteen round miniatures of the Romanov rulers, painted on ivory by Zuiev, each one framed in diamonds.

Releasing a knurled gold knob opens the egg; inside is a blue steel globe of the world, partly gilded, and constructed in two halves. One half shows the extent of the Russian Empire in 1613, the other half, the Empire in 1913. And in fact, in the tercentenary year, Nicholas and Alexandra made a pilgrimage that traced the route of Michael Romanov, founder of the dynasty, on his way to the throne.

The egg is supported on the wings of a triple imperial eagle of sculptured gold. The eagle holds the symbols of power in its claws—a sword, an orb, and a scepter. A circular base of red purpurine, mounted in gold and studded with small enameled buttons, serves as the support for the entire ensemble.

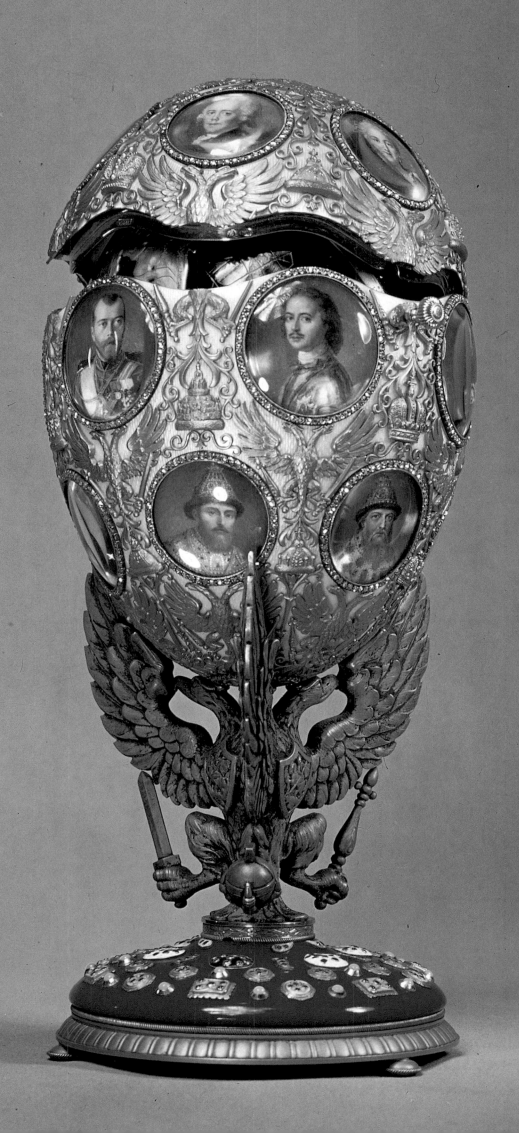

IMPERIAL MOSAIC EGG

1914

Height 3⅝" (9.2 cm). The Royal Collection, London.
Collection of H.M. Queen Elizabeth.

This most unusual egg employs a technique that intentionally simulates petit-point embroidery. This technique involves filling in a canvas mesh with small stitches in silk or wool yarn. Here, in the Imperial Mosaic Egg, a fine mesh of platinum is set with myriad tiny, square-cut stones, both precious and semiprecious, to create the background as well as the floral designs. One can imagine what a painstaking process it must have been. Rubies, sapphires, diamonds, emeralds, garnets, topazes, and quartzes shape and color the various sections of the egg, including five oval panels bordered by seed pearls with white enamel filets and joined with diamonds. Smaller diamonds, set in a wave pattern, band the egg near the top and bottom, and at the top there is a large moonstone under which the monogram of Czarina Alexandra Feodorovna is displayed.

Shown here is the reverse side of the surprise, an oval plaque on a beautifully enameled and jeweled stand. The plaque, painted in monochrome enamel, pictures a basket of flowers on an oval green background. It also includes the names, in Cyrillic script, of the five children of Nicholas and Alexandra, as well as the date, 1914. The plaque, bordered on both sides with diamonds, is framed in pearls and green-enameled husks and is topped by an imperial crown of diamonds. On the front side there is a cameo-style representation of the children's heads on a pink enamel background.

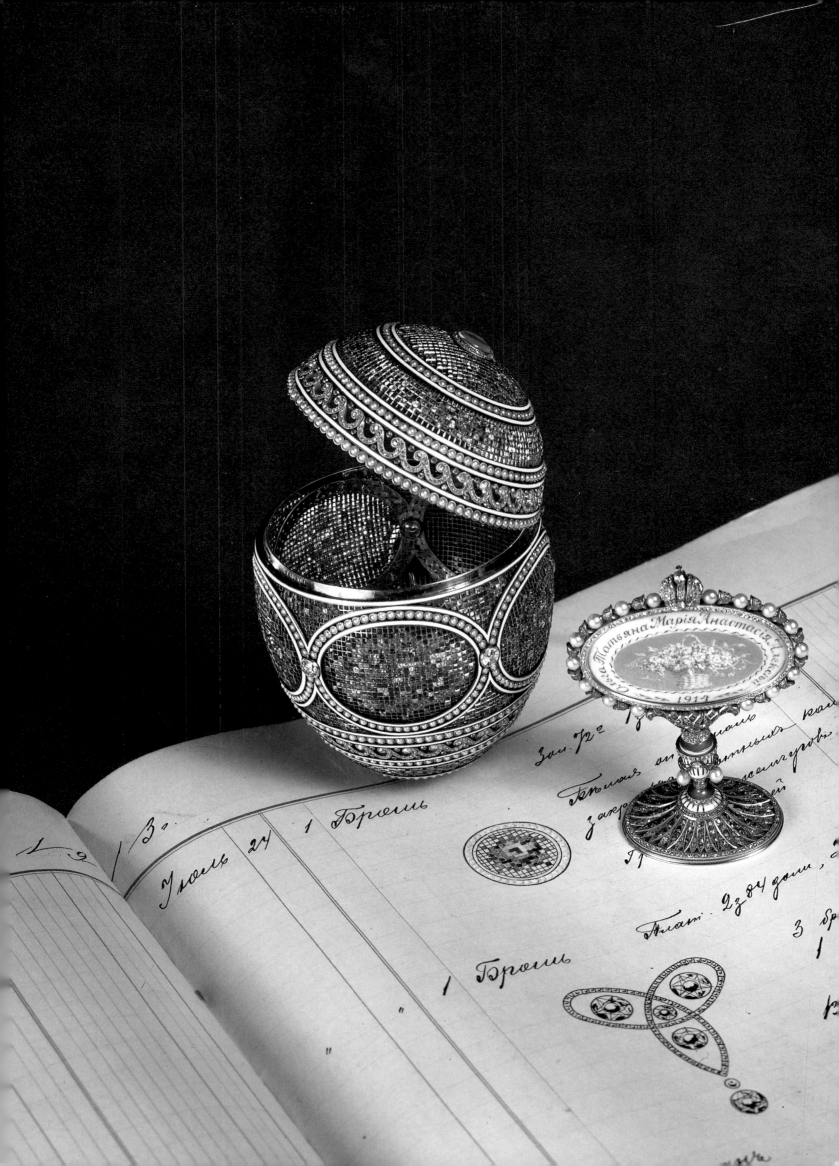

IMPERIAL CAMEO EGG
1914

Workmaster Henrik Wigström, St. Petersburg. Height 4¾" (12 cm).
Courtesy of Hillwood Museum.

This highly embellished egg of four-color gold was given by Czar Nicholas II to his mother, the Dowager Empress Marie Feodorovna. Its most important feature is a series of cameo-style panels painted by Zuiev, who also executed the miniatures for the Imperial Fifteenth-Anniversary Egg and the Imperial Napoleonic Egg, among others. The scenes on the Imperial Cameo Egg are done in off-white monochrome on a translucent pink ground, after the eighteenth-century French painter François Boucher. The large central panels are allegories, the one in front representing the arts, the one in back the sciences. Other panels depict putti personifying the four seasons. The panels are outlined in seed pearls and accented with sprays of diamonds. A portrait diamond at the top of the egg bears the cipher of Marie Feodorovna, while a similar diamond at the bottom carries the date 1914.

Although the surprise is now lost, we learn from a letter written by Marie to her sister, Queen Alexandra of England, that it was a little automated sedan chair. It was carried by two bearers, and a figure of Catherine the Great was seated inside. Another automaton fitting this description exists, but since it is a bit too large to fit into the Imperial Cameo Egg, it is not considered to be the actual surprise made for this particular egg.

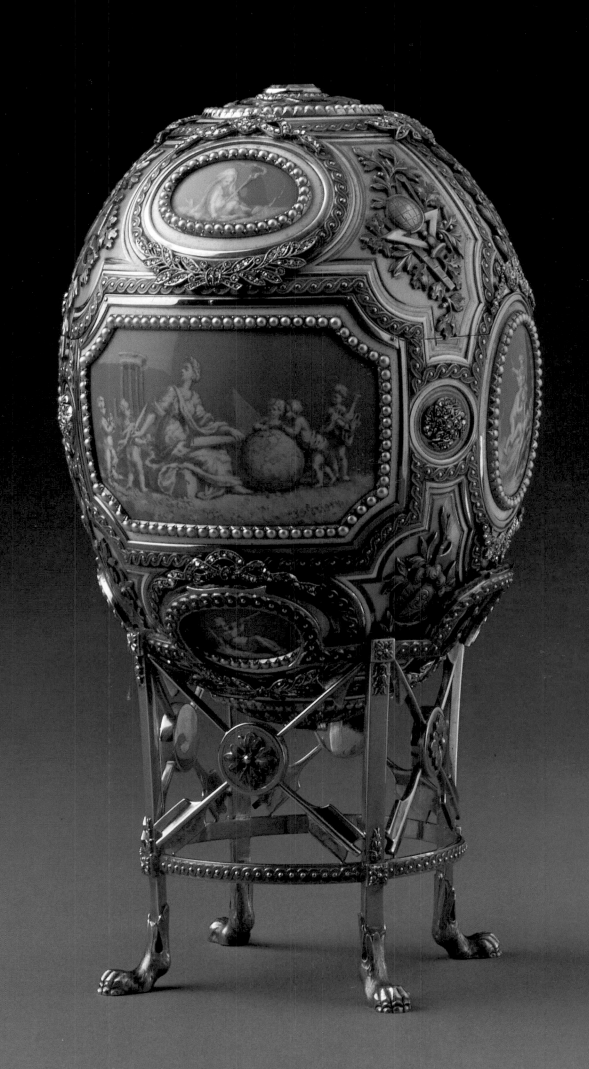

IMPERIAL RED CROSS EGG
WITH PORTRAITS

1915

Workmaster Henrik Wigström, St. Petersburg. Height 3½" (8.9 cm).
Virginia Museum of Fine Arts, Richmond.
Bequest from the Estate of Lillian Thomas Pratt, 1947.

Compared to the exuberant ornamentation of most of the other imperial eggs, the decor of this Red Cross Egg is remarkably restrained. It is dignified, simple, and unadorned by so much as a single jewel. Presumably, Russia's role in the war against Germany at the time explains the relative austerity of the egg, which was presented to Dowager Empress Marie Feodorovna by Czar Nicholas II.

The egg is enameled in opalescent white over a machine-turned ground in various patterns, including moiré at the top and bottom. On each side there is a red-enameled Greek cross, flanked by the dates 1914 and 1915. Running around the center in stylized, gold Cyrillic lettering is the biblical legend, "Greater love hath no man than this, that he lay down his life for his friends."

The Dowager Empress was president of the Red Cross in Russia, and the surprise contained in this egg makes reference to that fact. It is a five-panel folding screen, also relatively plain in design, depicting the Empress's daughter-in-law, Czarina Alexandra Feodorovna (center), and Alexandra's four daughters, all wearing Red Cross nursing uniforms. Painted by the miniaturist Zuiev on mother-of-pearl, the oval portraits are bordered in gold and set into ribbed-sunburst *guilloché* panels enameled in white, each topped by a roundel with a miniature red cross. The stark simplicity of the design and the poignancy of the theme make an unforgettable impression.

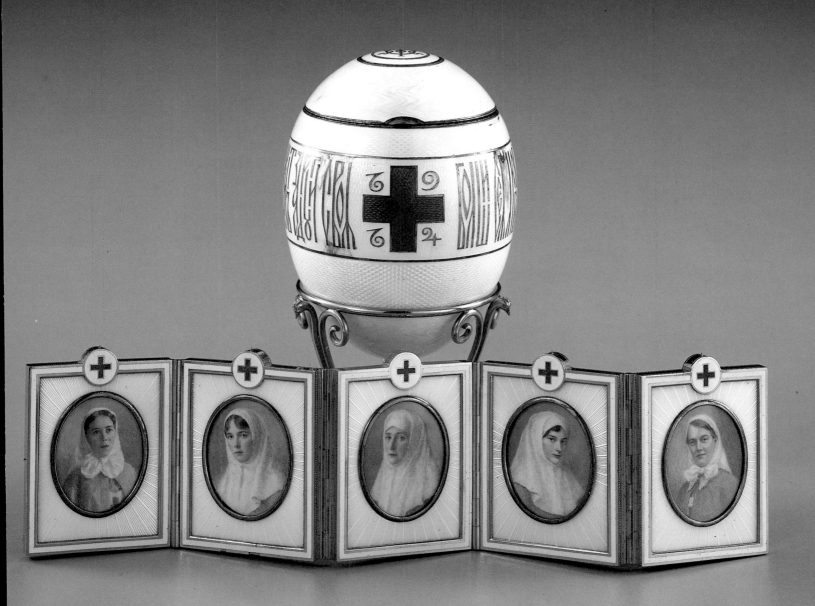

IMPERIAL CROSS OF ST. GEORGE EGG
1916

Height 3⁵/₁₆" (8.4 cm).
The Forbes *Magazine Collection, New York.*

This is the last imperial egg that the Dowager Empress Marie Feodorovna received from her son Nicholas, and it foreshadows the tragic final chapter in the history of the imperial family and of the Romanov dynasty. Because the Empress was not with the Czar and his family at Easter in 1916, she was able to avoid capture, and she made her escape—aided by King George V of England—from Russia at a later date. The Imperial Cross of St. George Egg was the only egg she managed to take with her. She died in her native Denmark in 1928.

The Cross of the Order of St. George, which Nicholas II conferred upon himself, is a recurring motif in this egg. Enameled in opalescent white with a matte finish, the egg's surface has a shadowy underpainting of leafy trelliswork in pale green interspersed with miniature red and white St. George crosses. A gold ribbon enameled in black and orange, representing the sash of the order, is applied to the egg in loops, swags, and bows. On each side is a hinged medallion that appears to be suspended from a bow and that opens by releasing a catch below. One medallion bears an enameled rendition of the Cross of St. George, complete with a miniature of St. George slaying the dragon. Under it is a portrait of Nicholas II. The other medallion is a silver St. George Medal engraved with the profile of Nicholas with a portrait of Czarevich Alexei underneath.

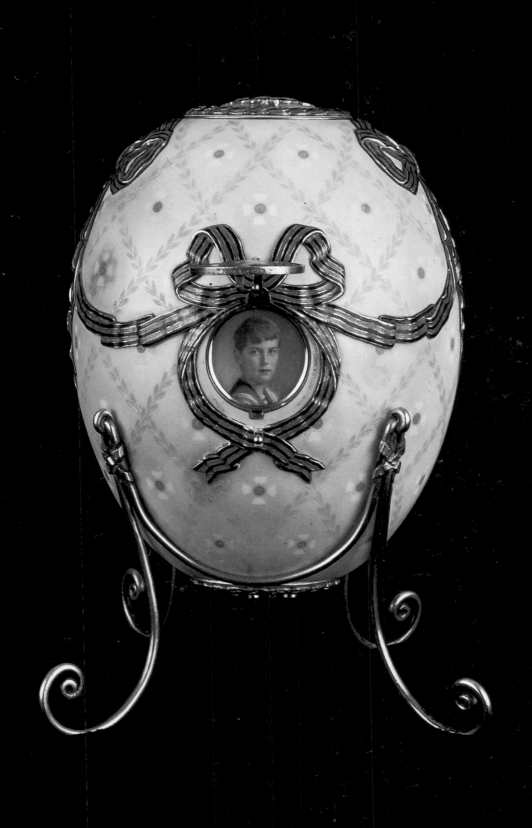

GLOSSARY

Bowenite: A pale green, jade-like mineral.

Cabochon: A precious stone rounded or domed and polished, but not cut into facets.

Champlevé: An excavated design in metal that is filled in with enamel.

Chapter ring: A ring or band on a clock that shows the hours.

Chasing: A decorative technique of engraving or carving metal by hand.

Cloisonné: A design in enamel formed of wires soldered to a surface to form cells, or *cloisons*; these are then filled with enamel.

Demantoid: A type of garnet considered the most valuable found in the Ural Mountains.

Enamel: A decorative coating fused to the surface of metal at high temperatures. The surface is smooth and glassy and may be transparent, translucent, or opaque, with a shiny or matte finish.

Filet: A narrow decorative strip used to frame an area or separate it from another.

Guilloché: Engraved (into metal) with a decorative design by means of a machine (*tour à guilloche*). Favored designs, such as basket-weave, moiré, and wave patterns, were usually finished with transparent enamel.

Machine-turned (or engine-turned): See *Guilloché*.

Pavé: Setting of stones close together with no metal showing.

Plique-à-jour: A design in unbacked wire that is filled in with enamel to create a translucent, stained-glass effect.

Purpurine: A man-made, dark red glassy substance used much as any mineral or hardstone.

Rococo: An ornate decorative style featuring the use of scroll-like motifs.

Rose (-cut) diamond: A flat-bottomed diamond whose top is cut into triangular facets.

Table (-cut) or portrait diamond: A thin diamond with a flat surface, frequently used as a lens or cover for a portrait or a monogram.

Tour à guilloche: A lathe-like machine used to engrave a decorative design on metal.

Underpainting: A painted design over which transparent enamel is applied so that the design is visible.